UNIVERSITY OF NOTTINGHAM

10 0640008 X

WITHDRAWN

FROM THE LIBRARY

D1638390

Bliss

University of Nottingham
Hallward Library

As we look back on our recent history, the period between the late 1960s and the early 1980s emerges as a poignant era. This was a golden age marked by belief in an improving world – a spirit captured in the postcards shown in this book. Produced predominantly in the Catholic countries of Europe (and in several cases by Catholic publishing houses, alongside postcards of Jesus, Mary, popular Saints and the Pope) these images reflect the social and material aspirations of Europeans, not long recovered from the years of post-war austerity. They express a wholesome faith in the family and, in common with religious iconography, seem to offer us models of an ideal moral order where consumer opportunities and domestic relationships complement each other in perfect harmony.

I first encountered cards of couples and families being sold in newsagents and old-fashioned stationery shops in Portugal during the 1980s, and gradually built up a collection by visiting similar shops around Mediterranean Europe. By the mid-1990s, these cards disappeared from the shelves, and are now only to be found at flea markets and postcard collectors' fairs.

Re-examining them in the 21st century, at a time of ironic detachment, sophisticated visual literacy and cynicism towards the institutions of marriage and family, they seem cheesy and naïve. Viewed as a genre we can have no illusion about their being constructed performances, projecting a fantasy of life. Yet, beyond their comic pleasures and the nostalgic details of out-of-date clothes and décor, they leave us with a powerful record of social desires at a particular moment in history. And despite their fakery, we can't help being charmed by their authentic innocence.

Martin Parr, May 2003

100640008X

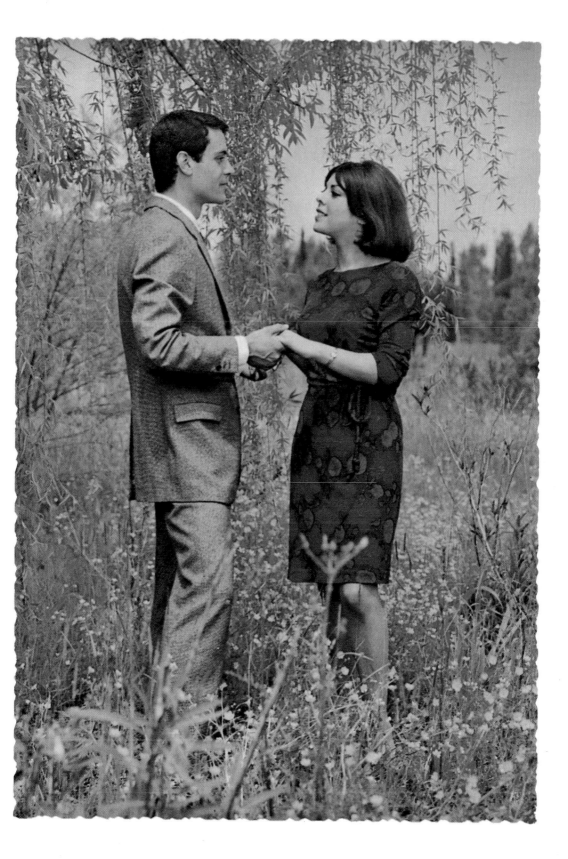

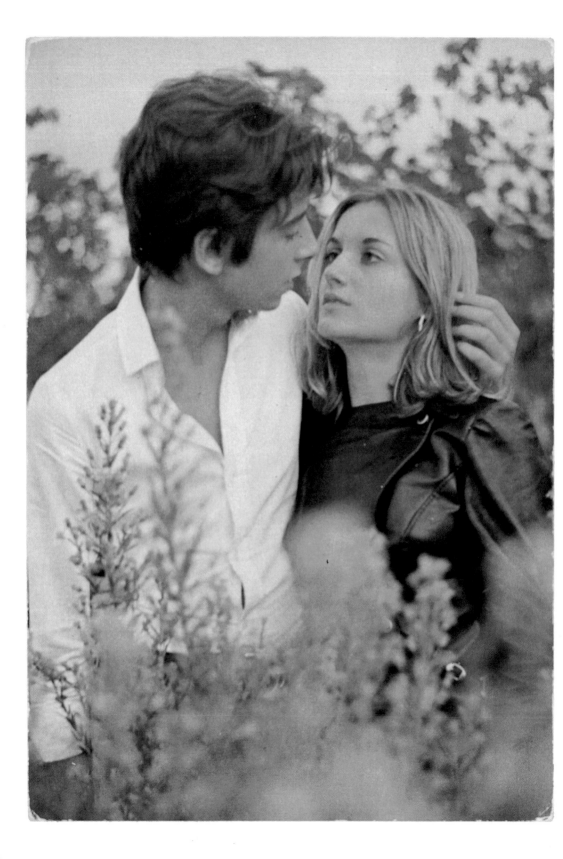

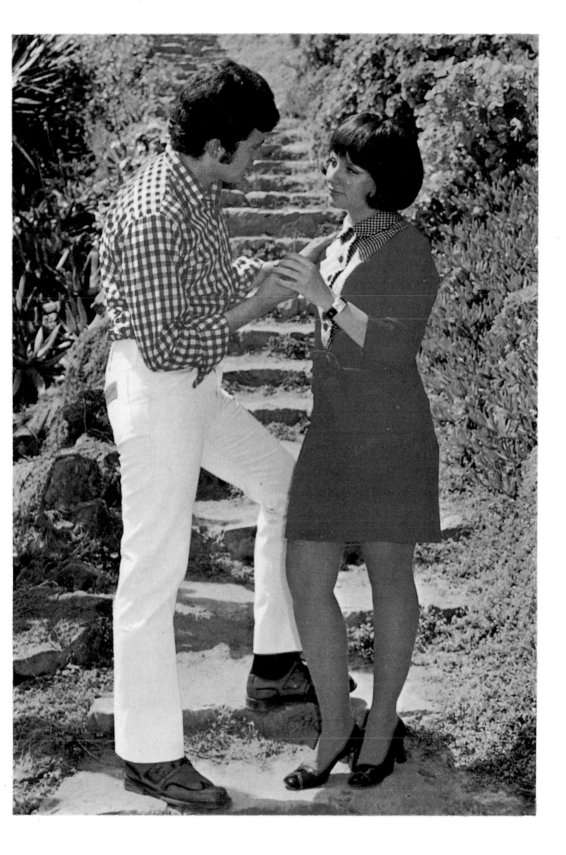

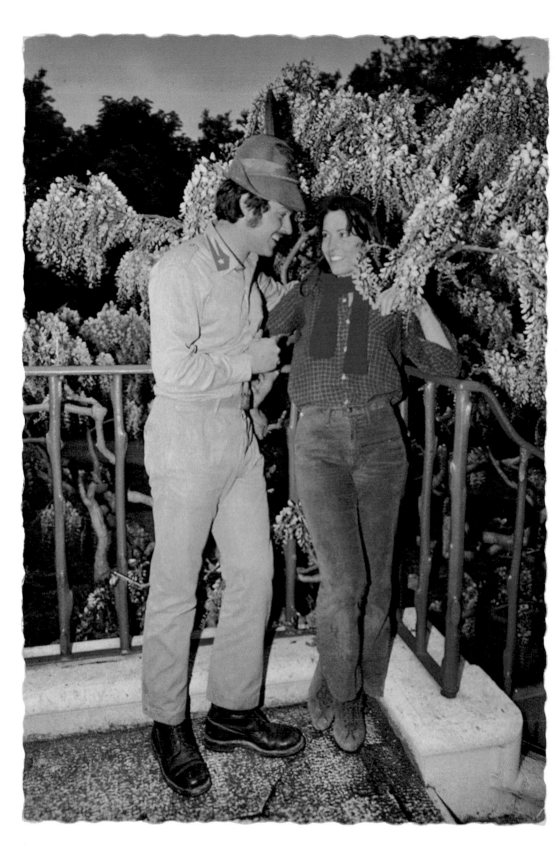

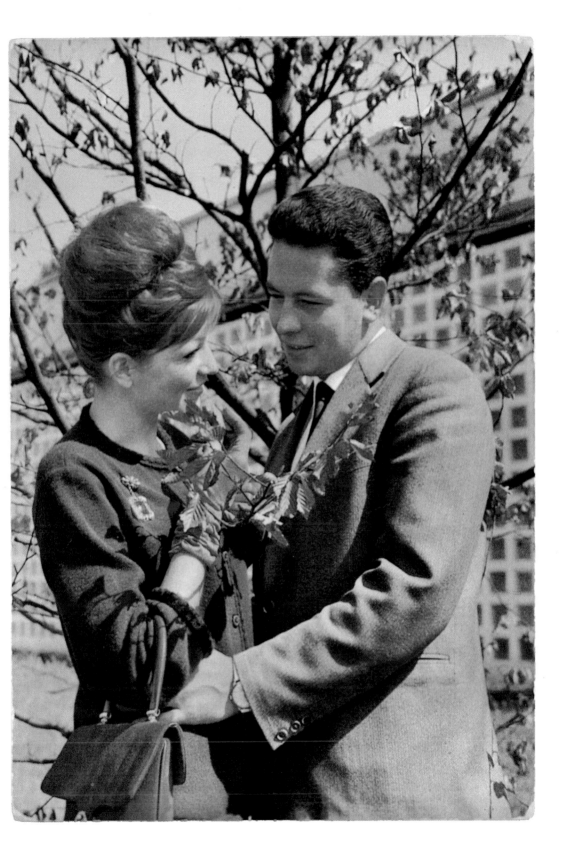

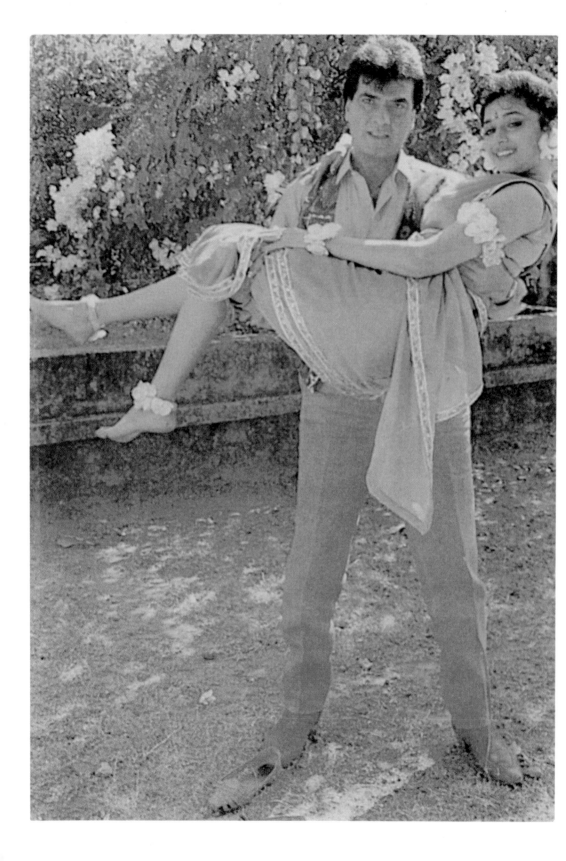

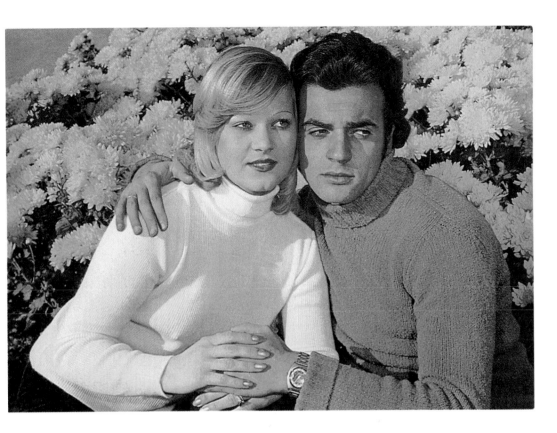

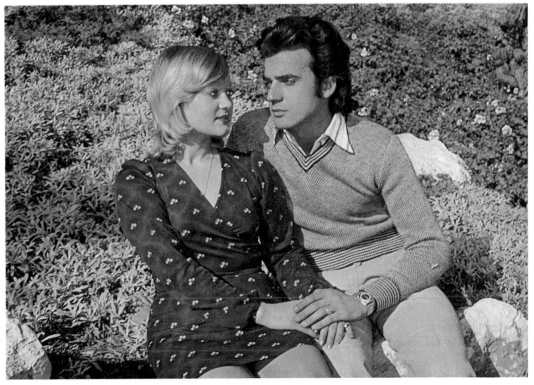

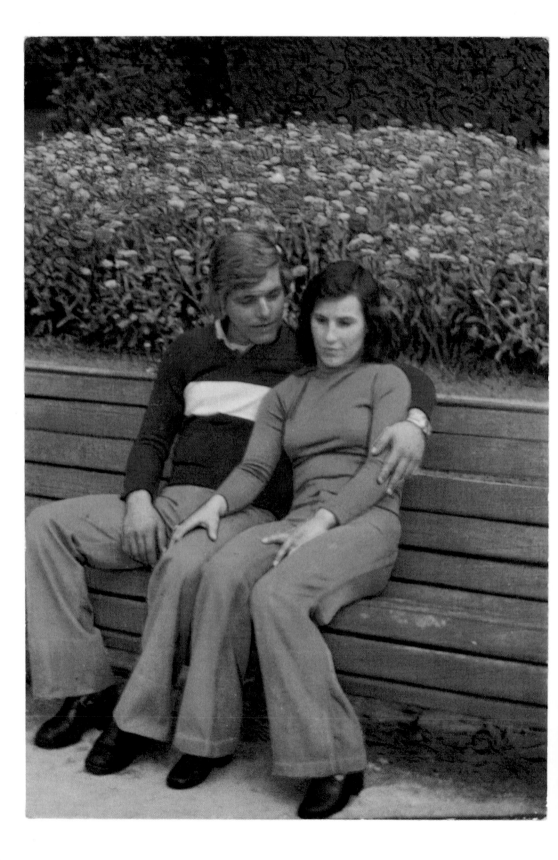

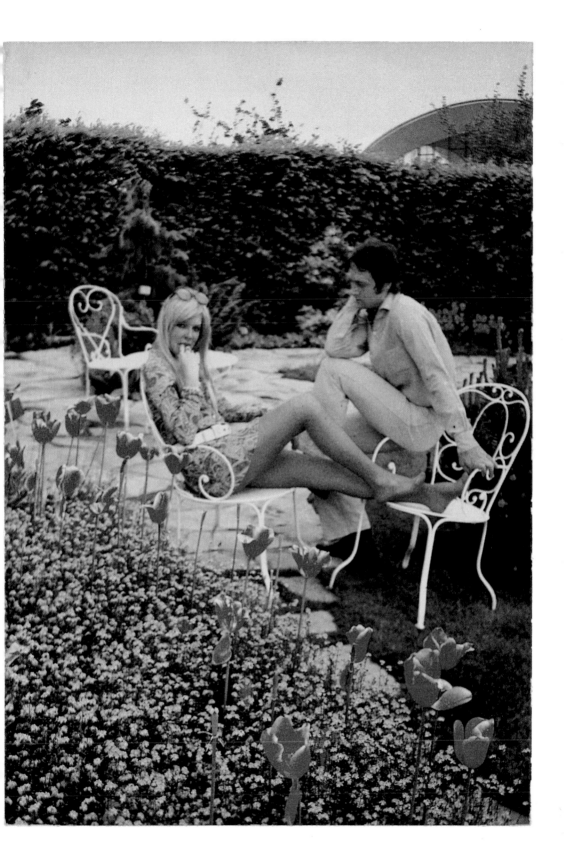

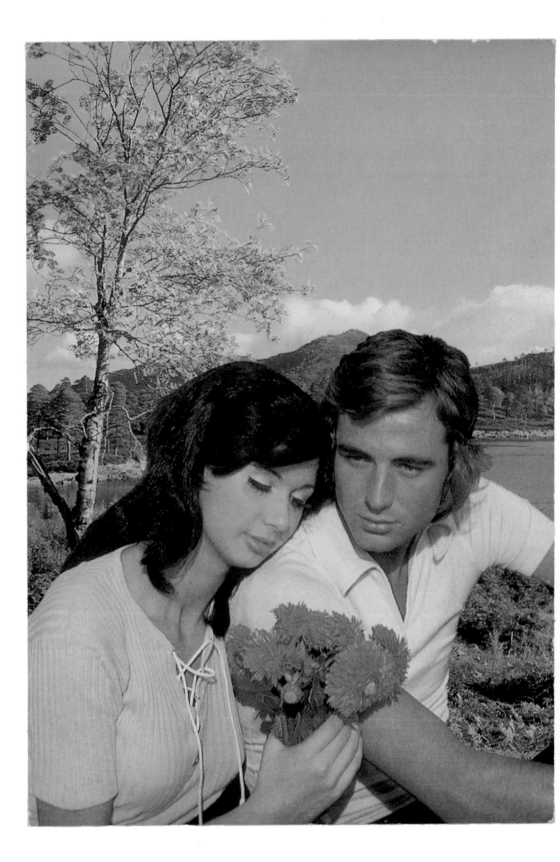

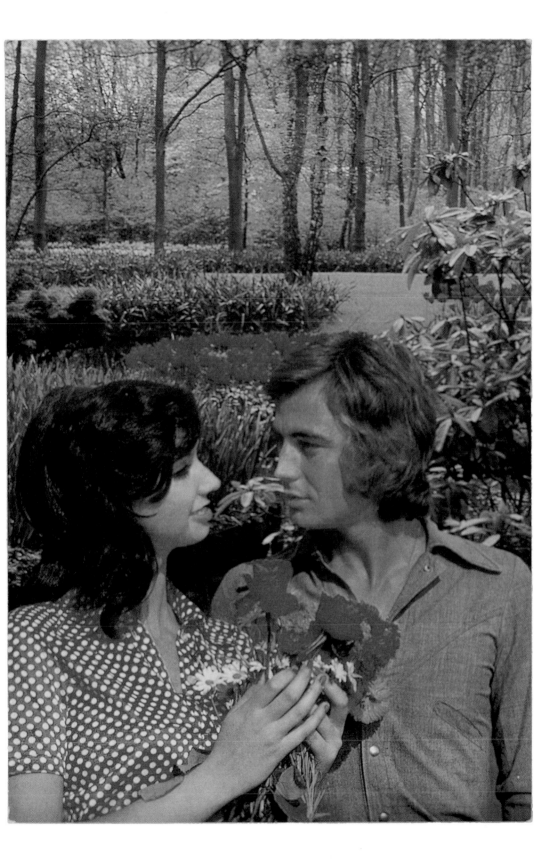

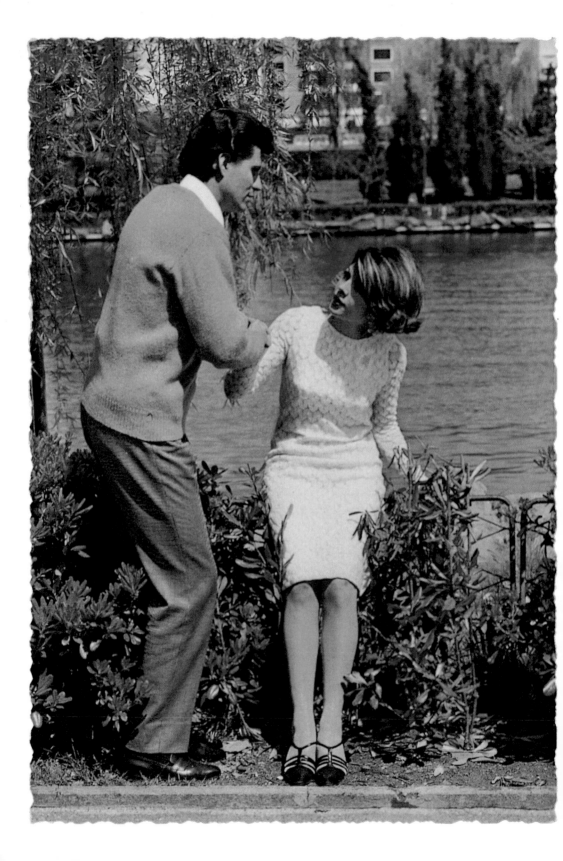

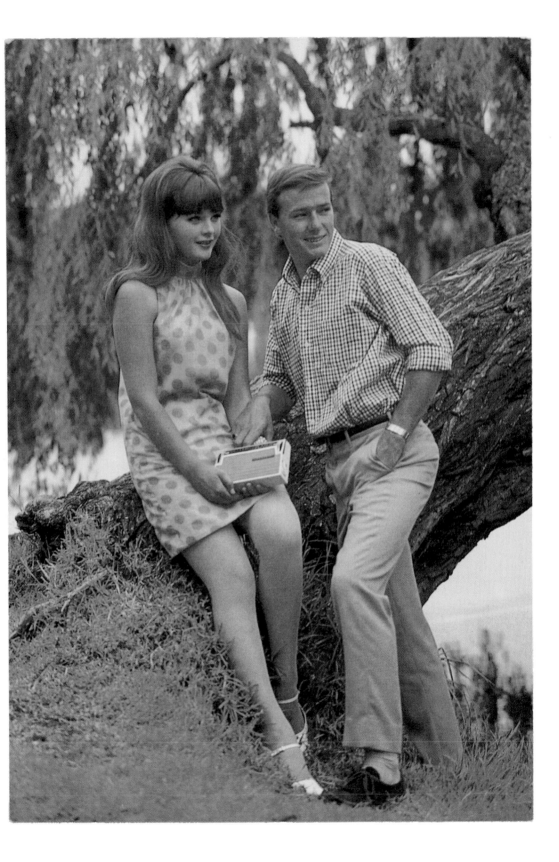

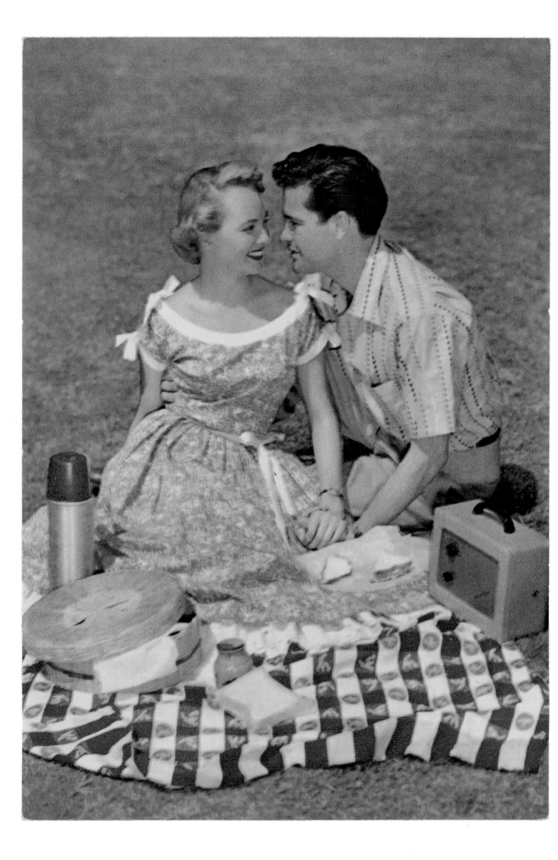

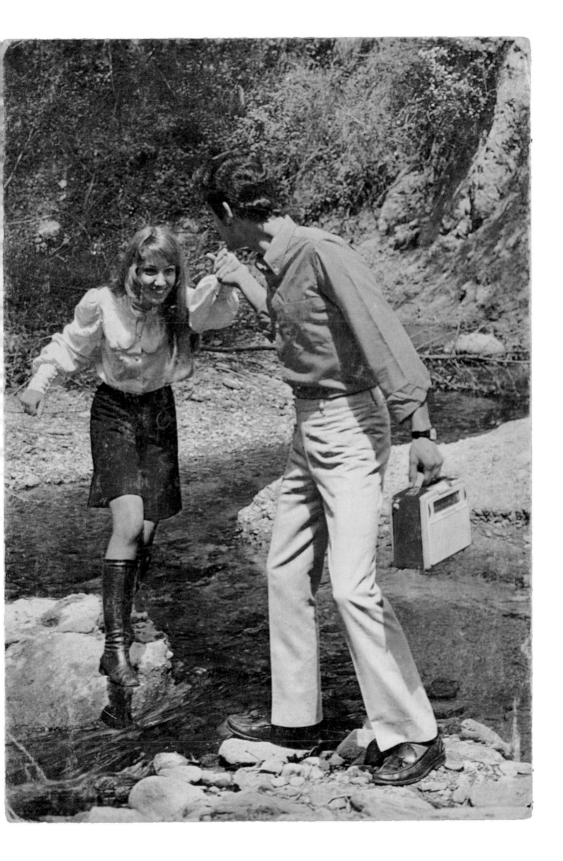

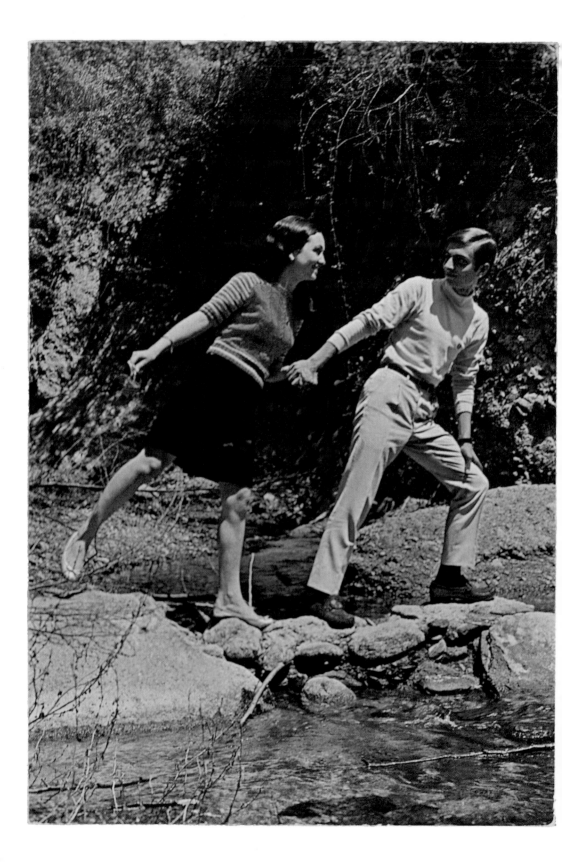

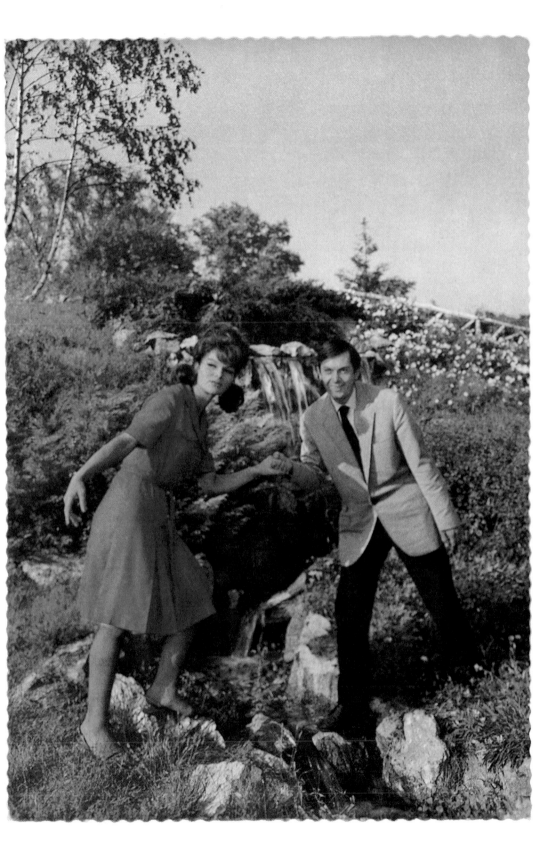

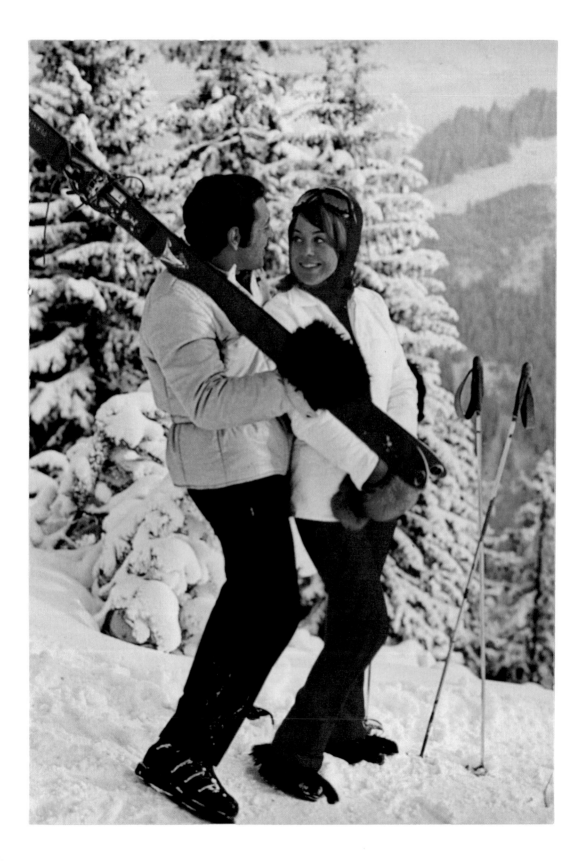

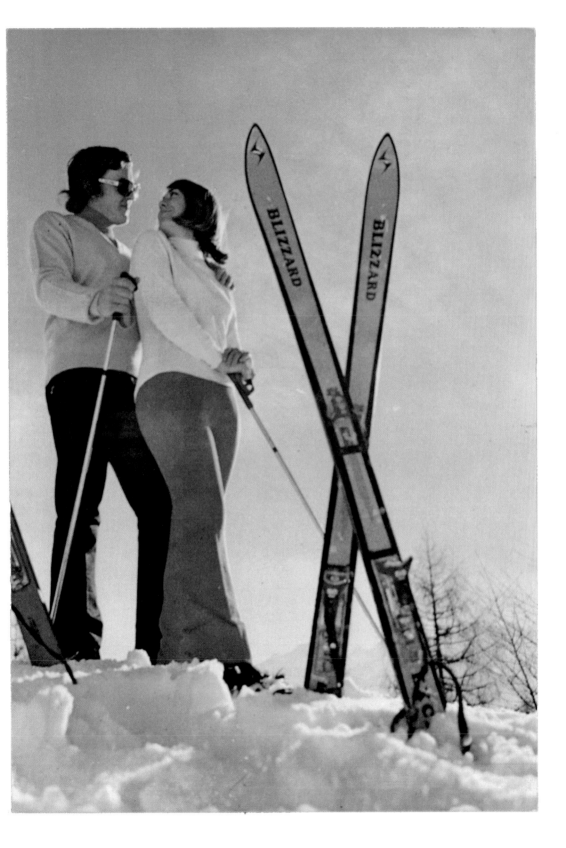

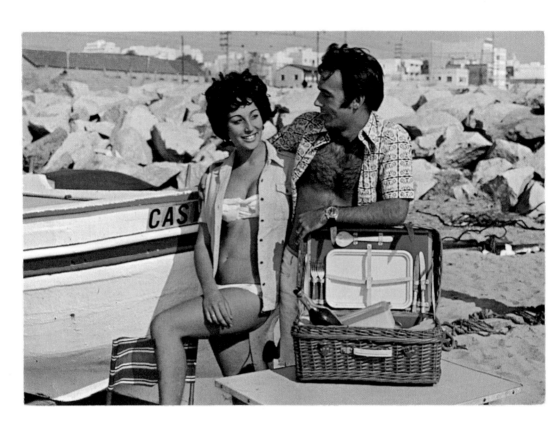

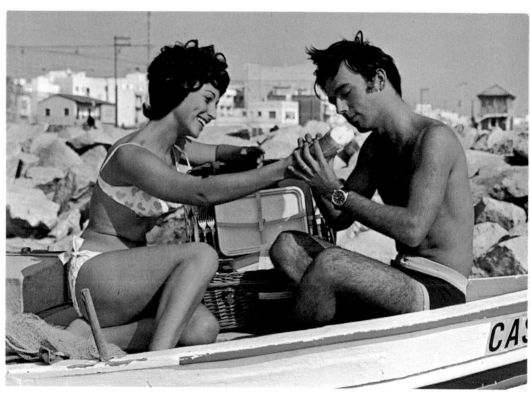

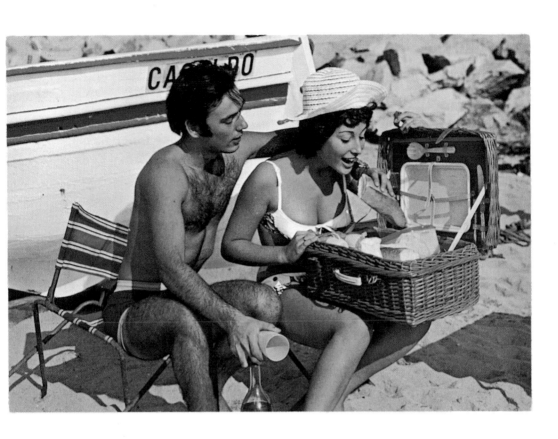

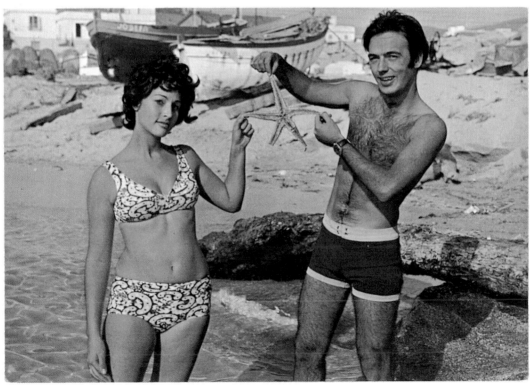

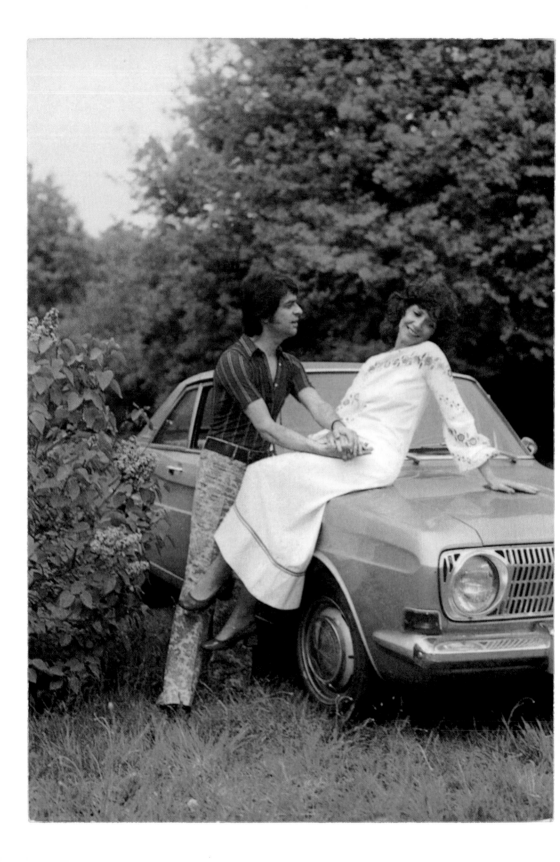

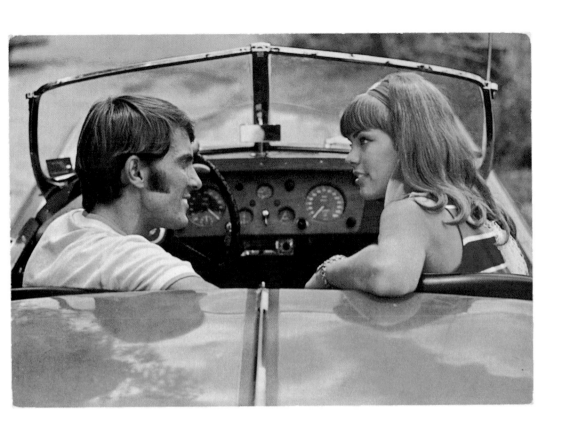

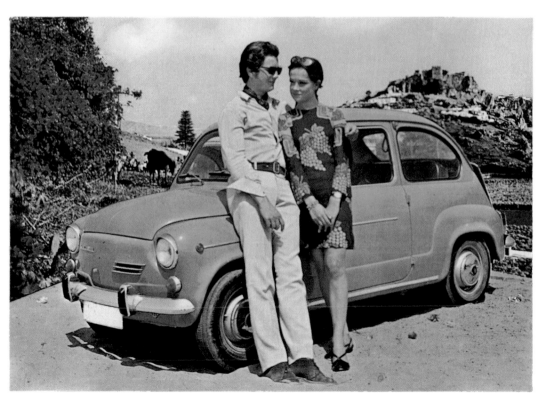

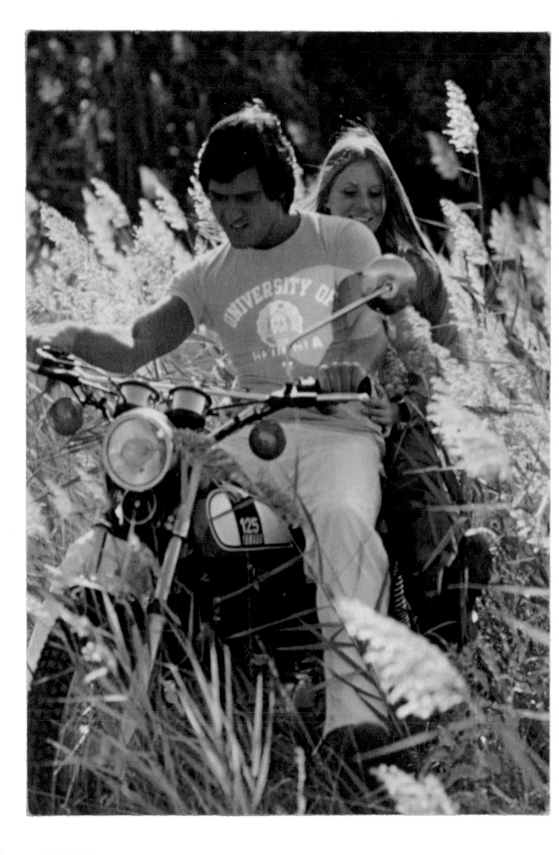

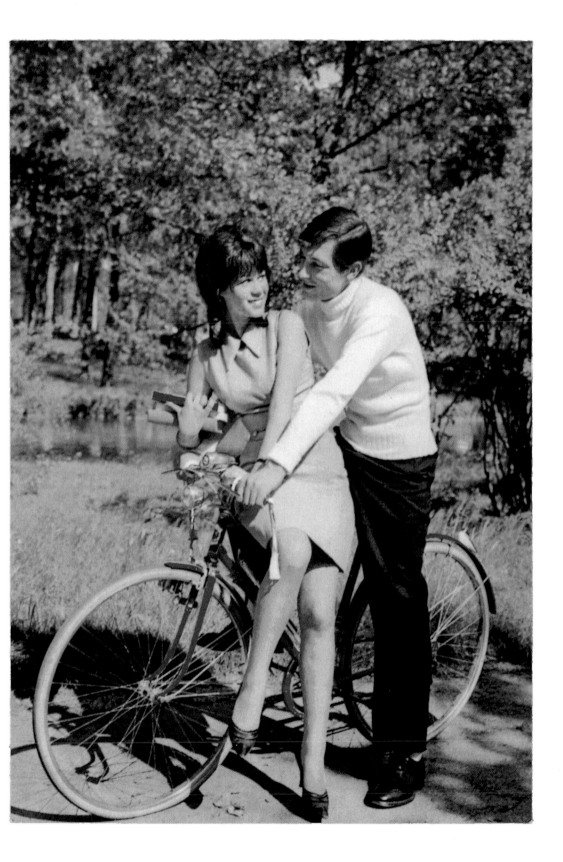

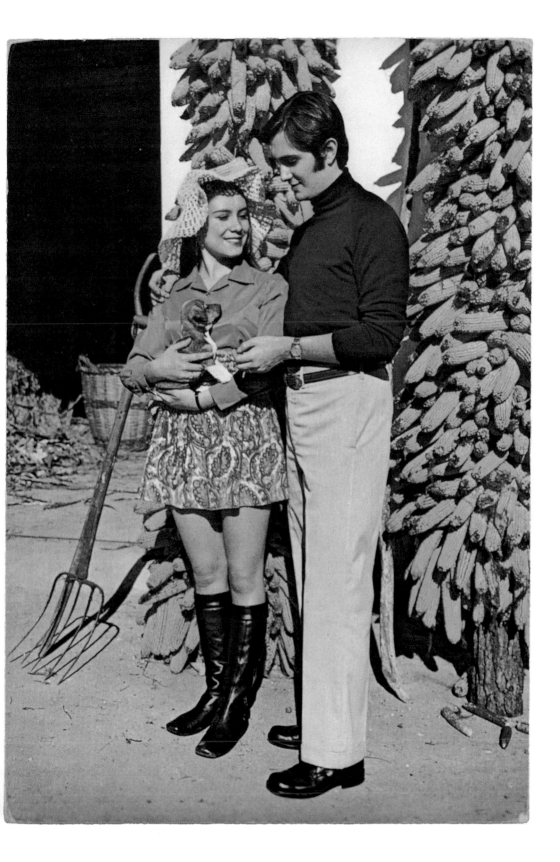

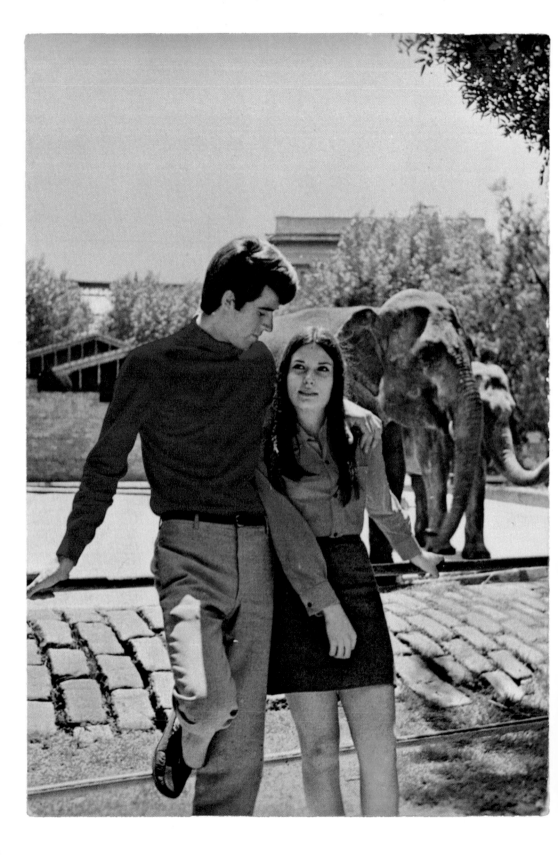

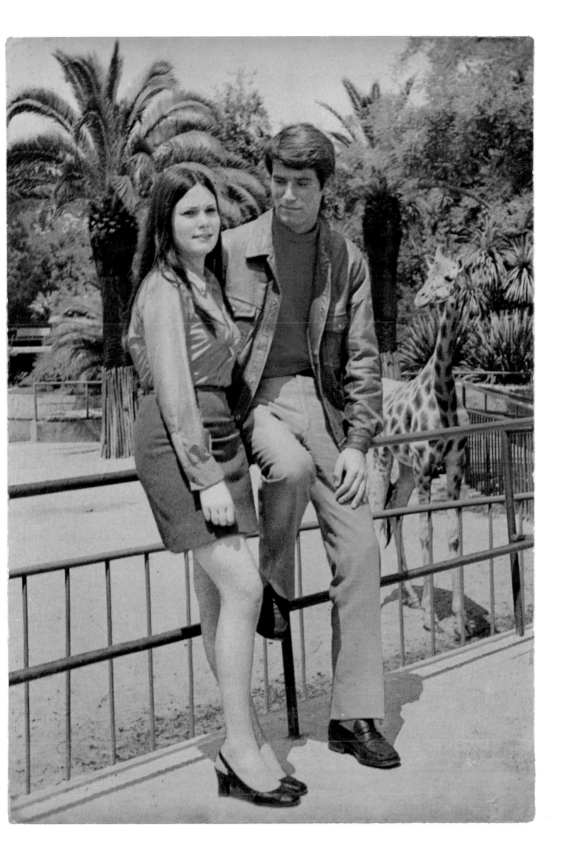

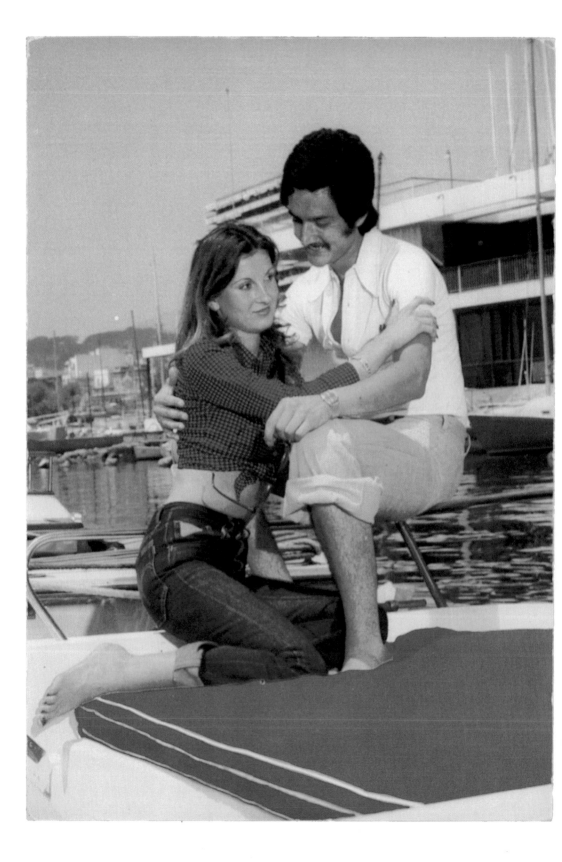

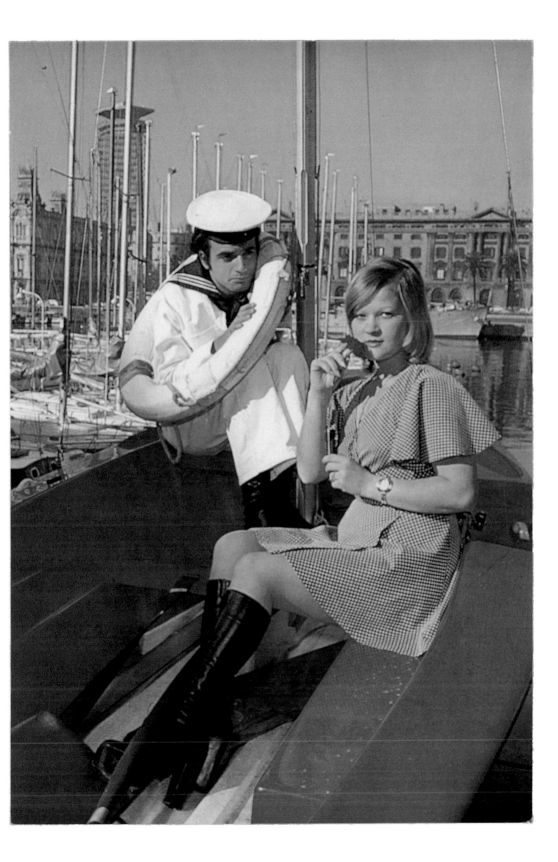

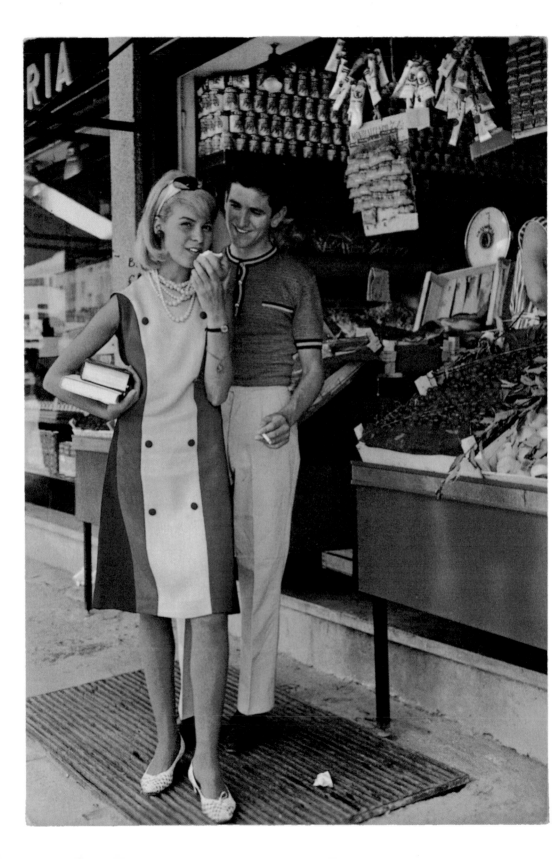

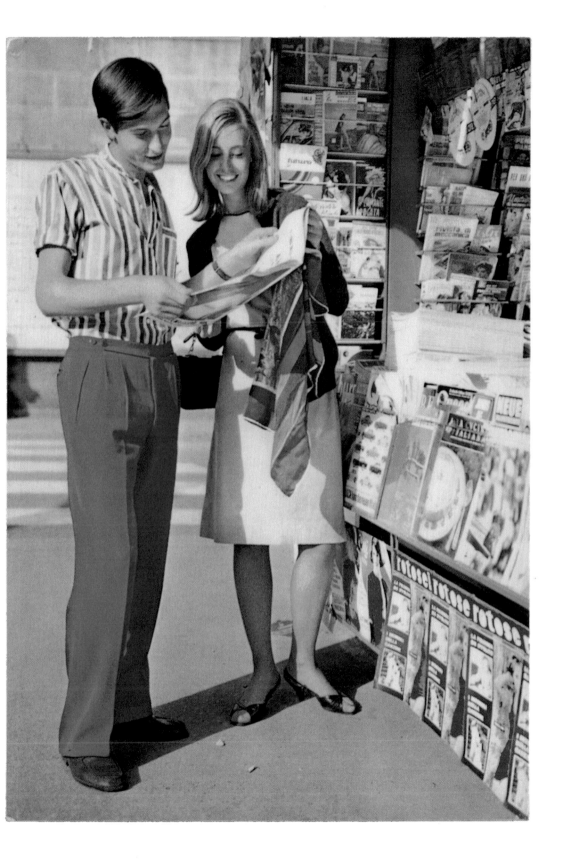

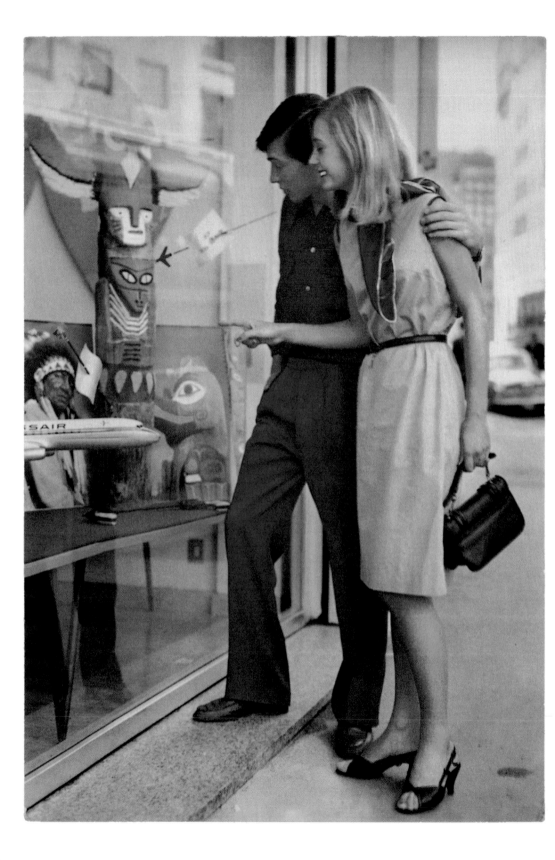

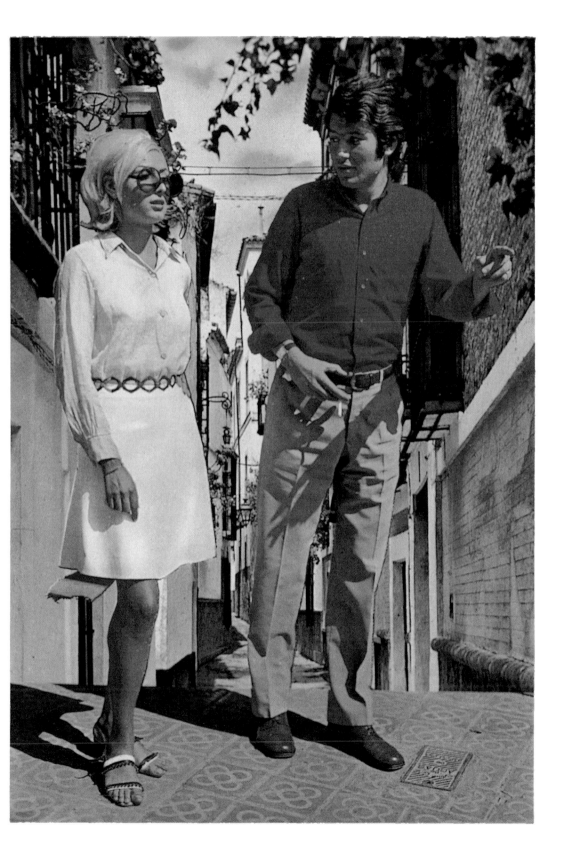

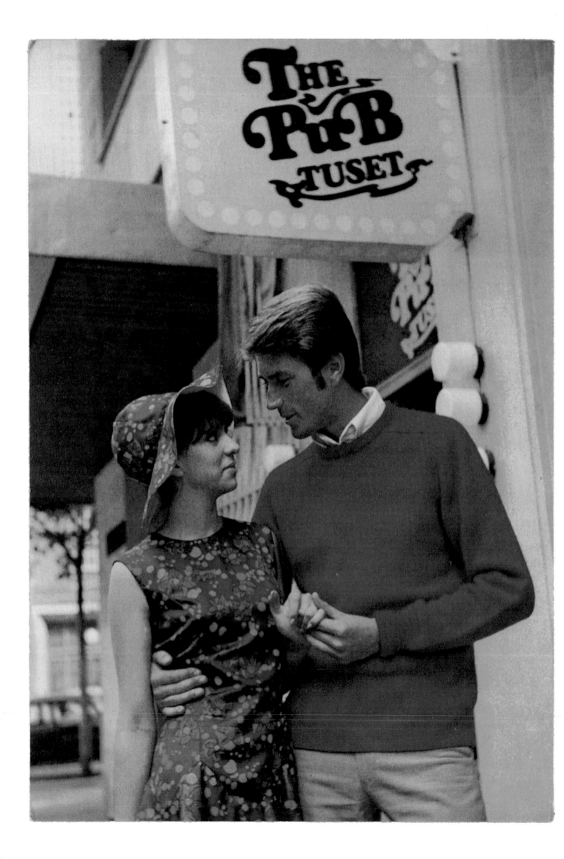

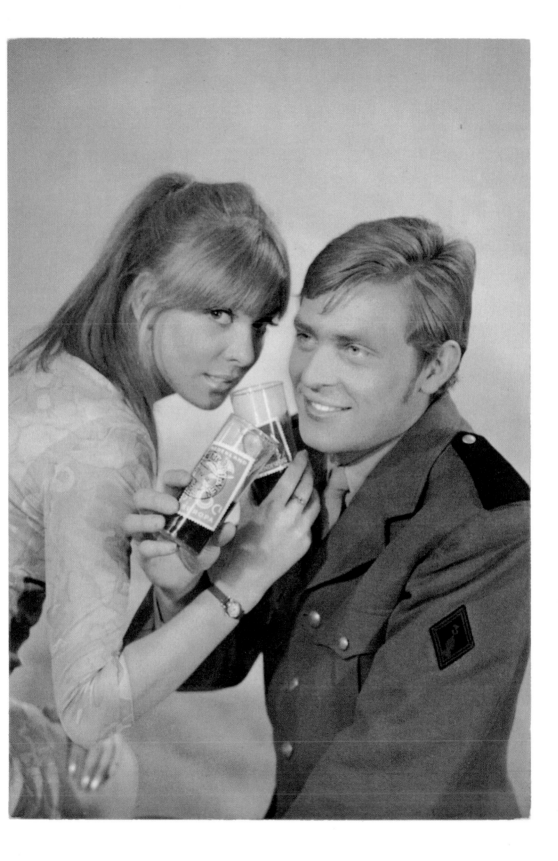

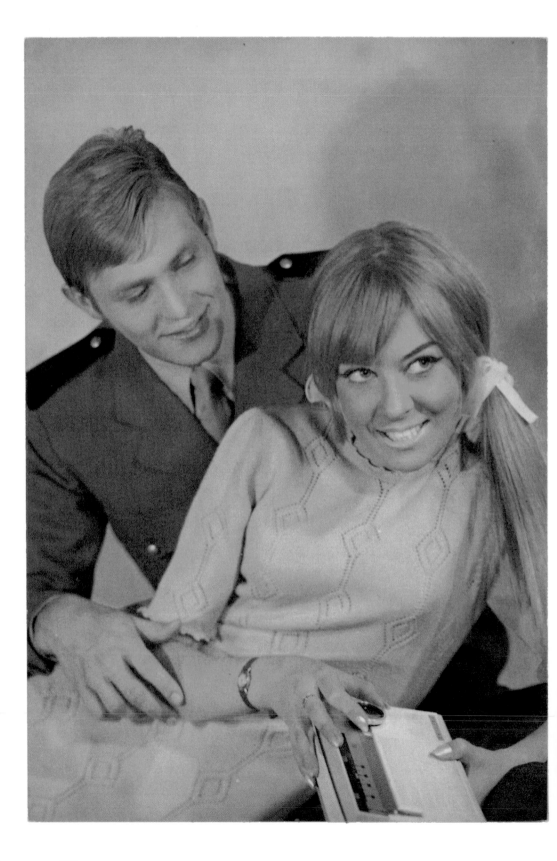

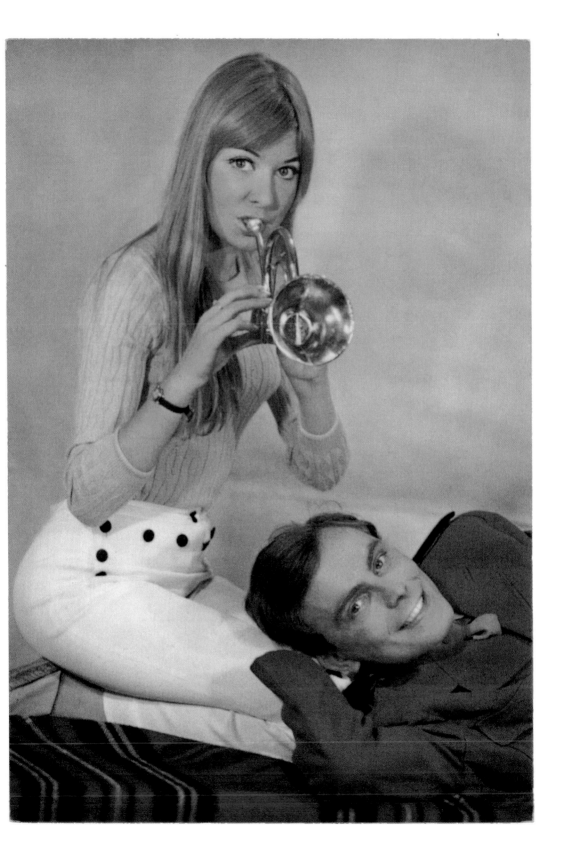

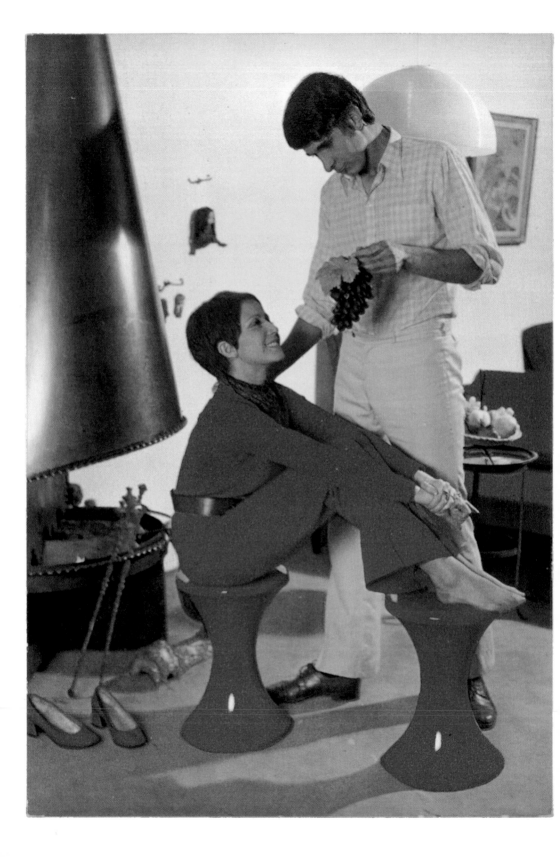

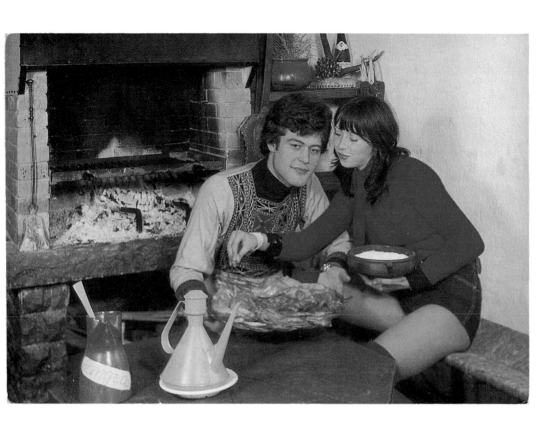

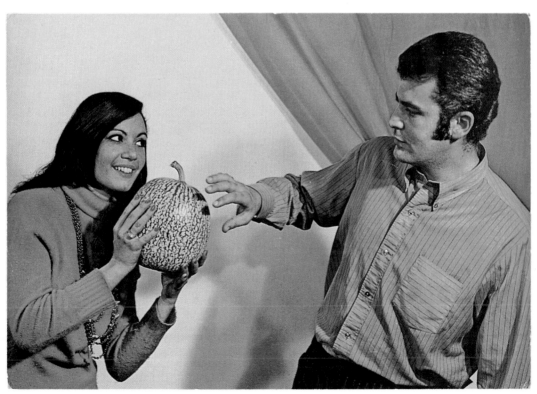

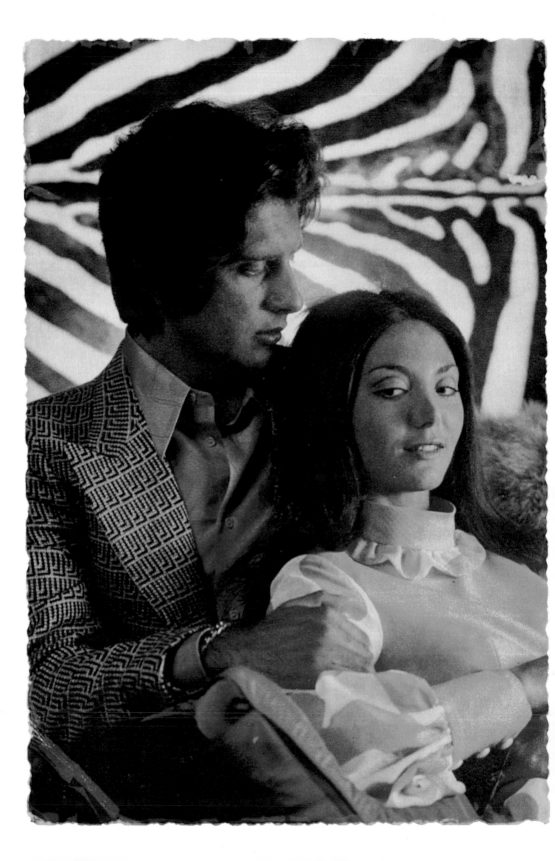

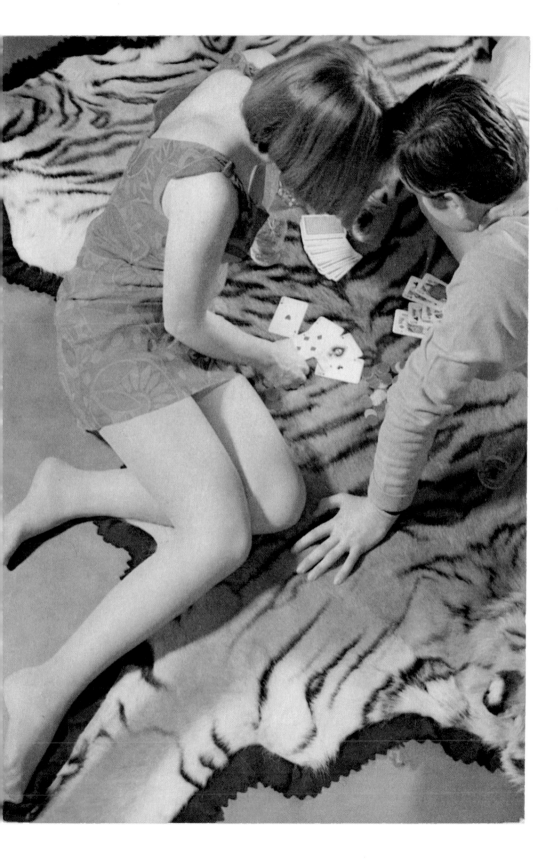

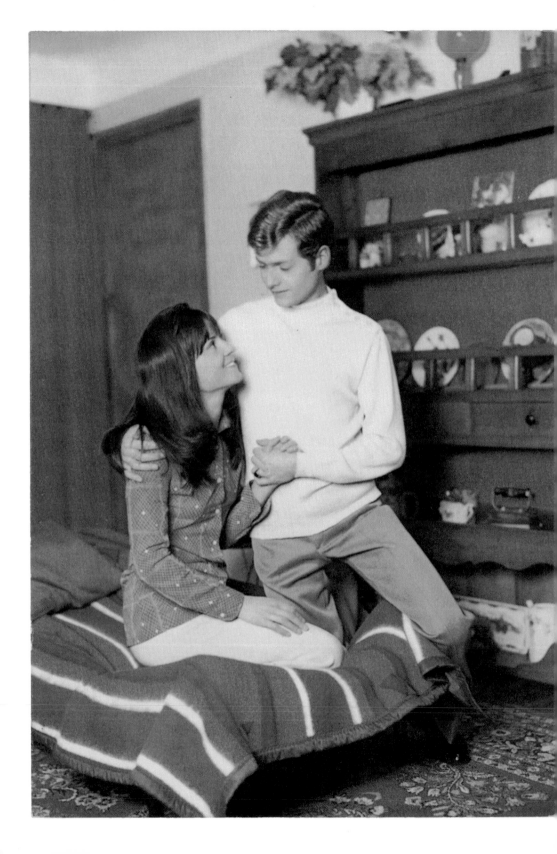

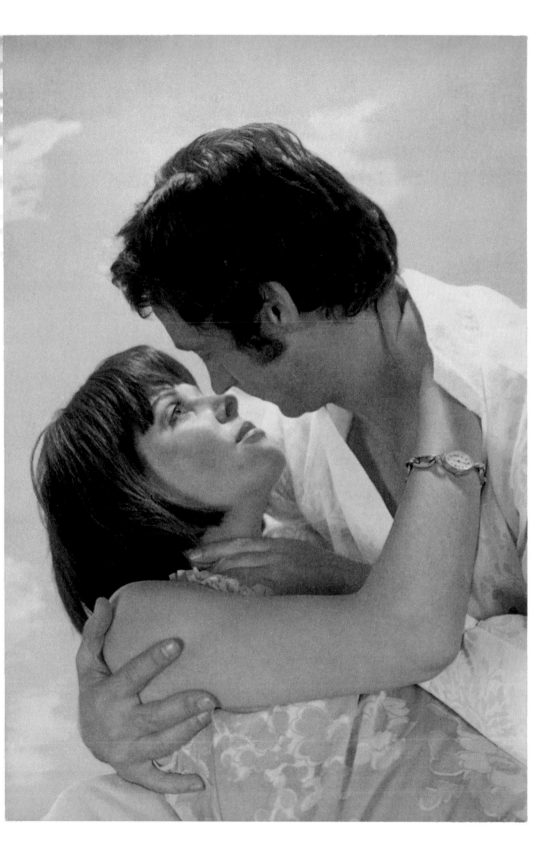

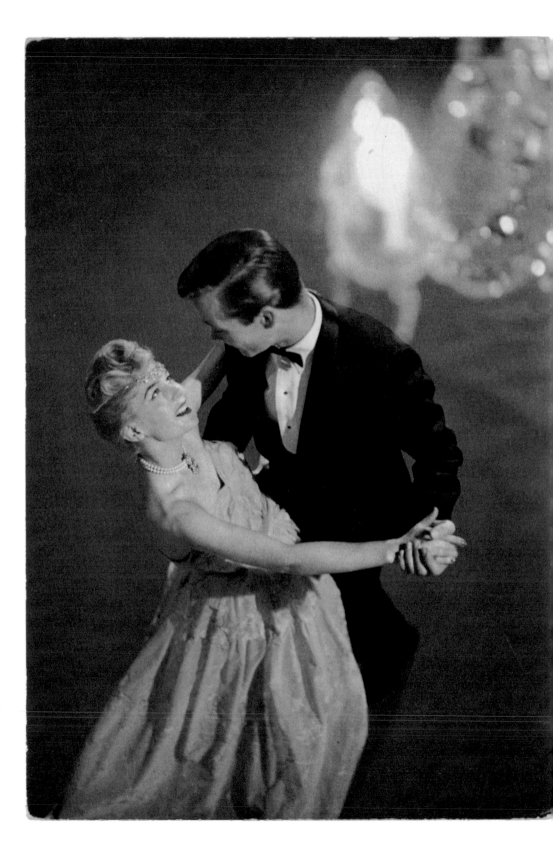

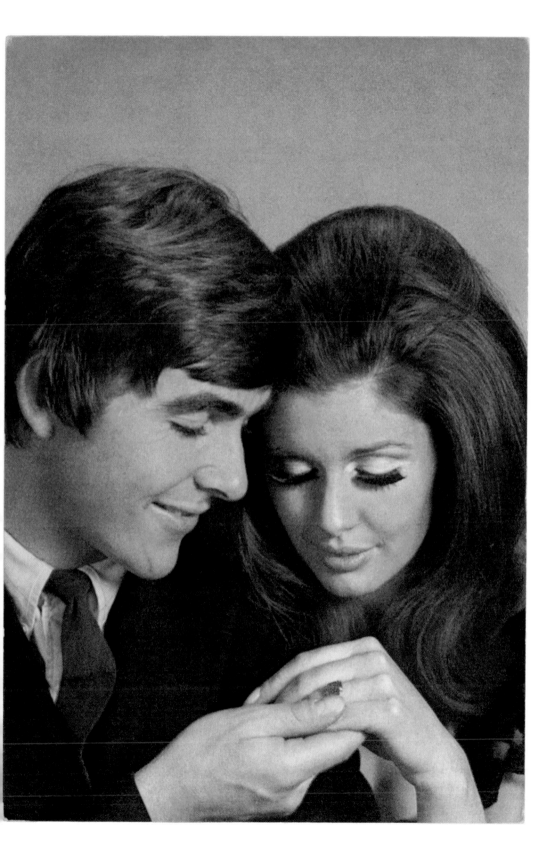

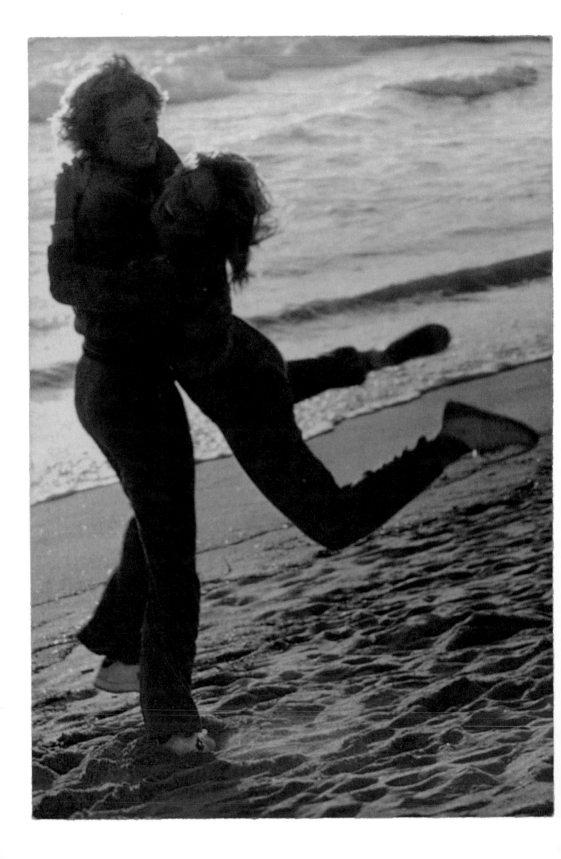

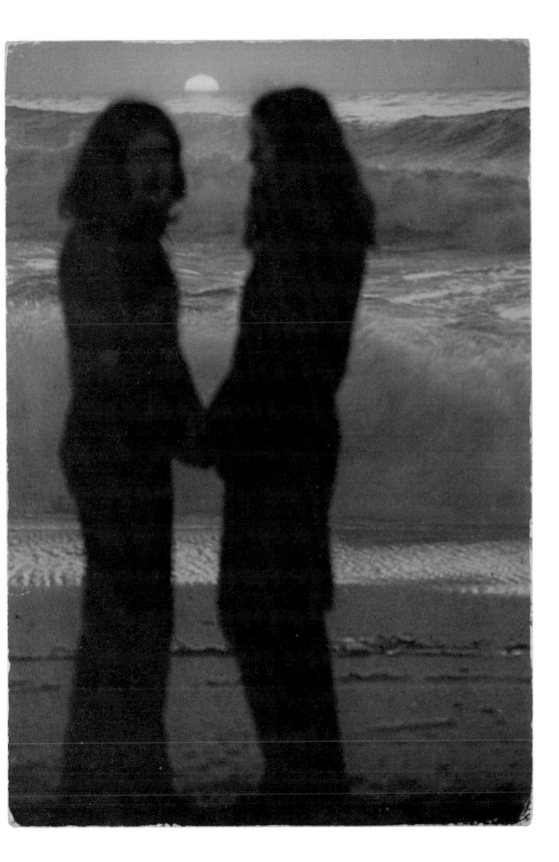

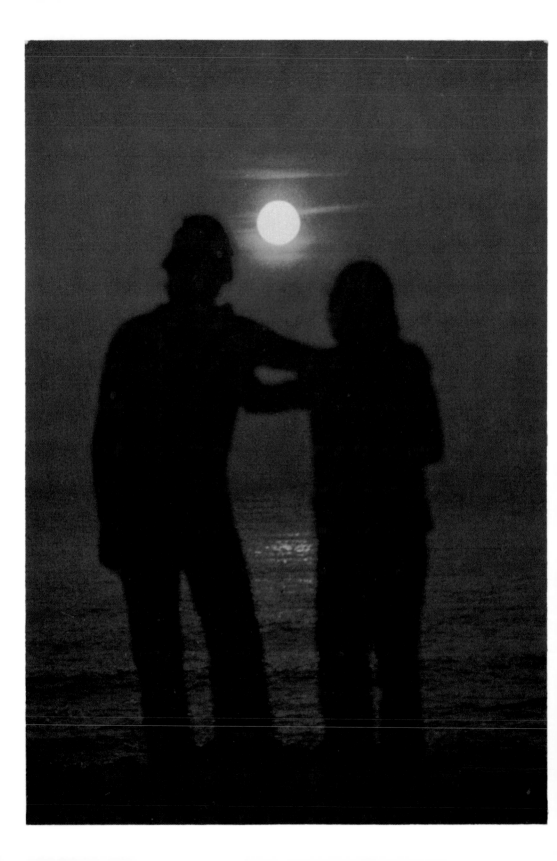

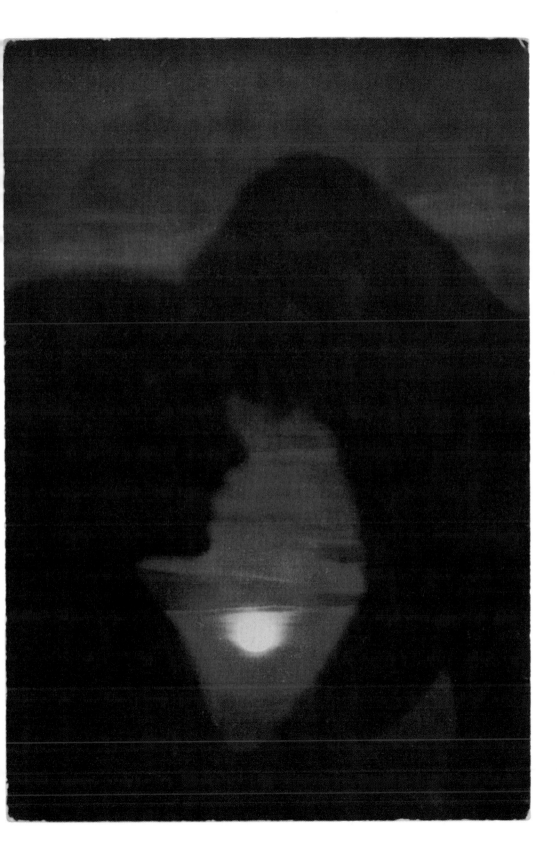

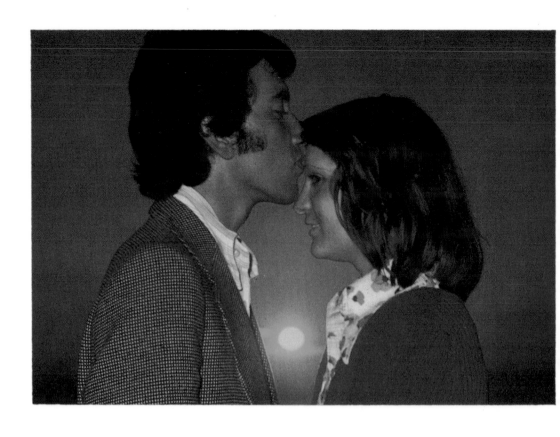
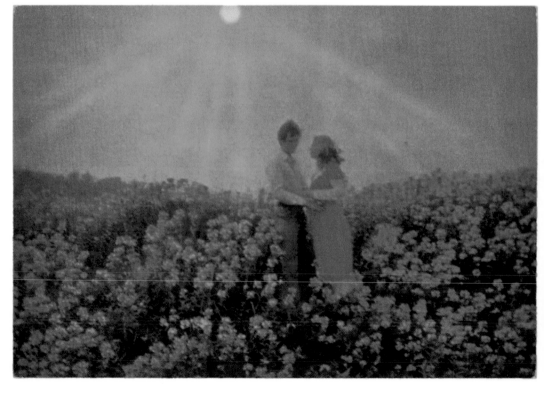

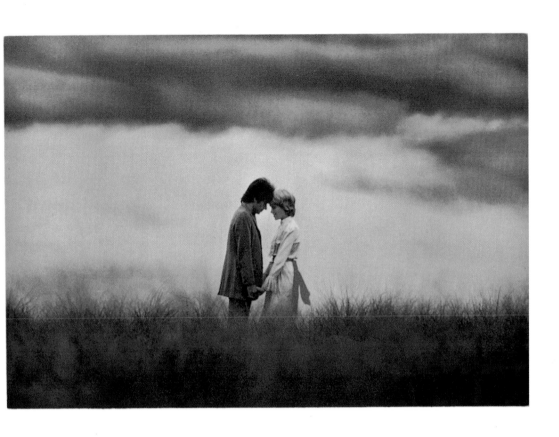

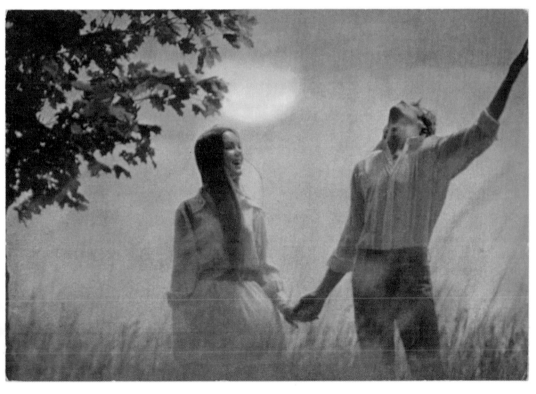

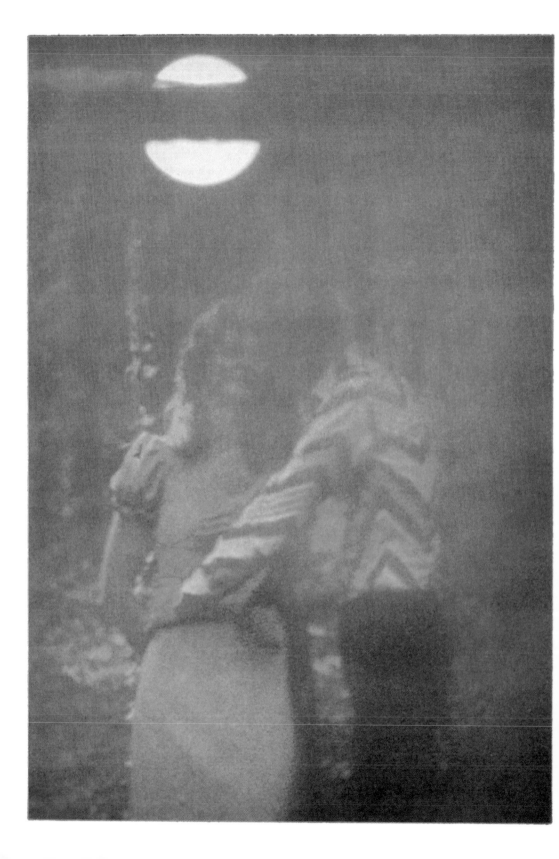

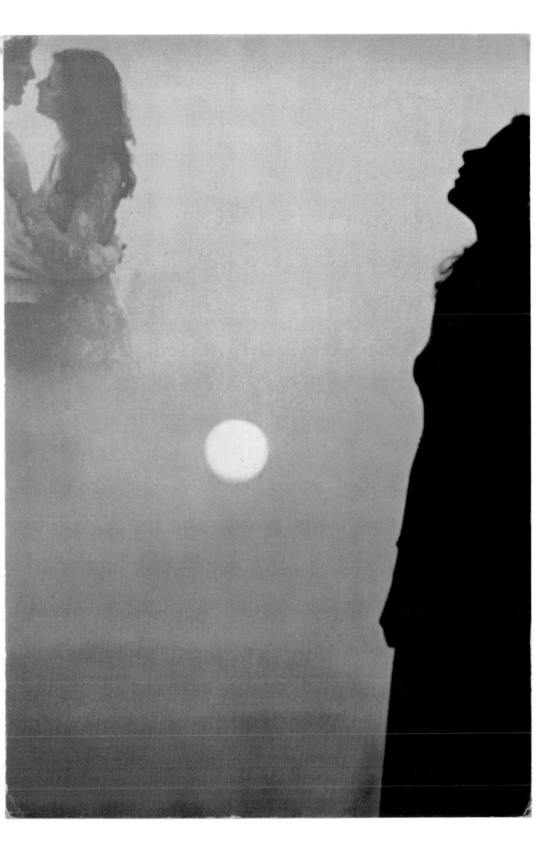

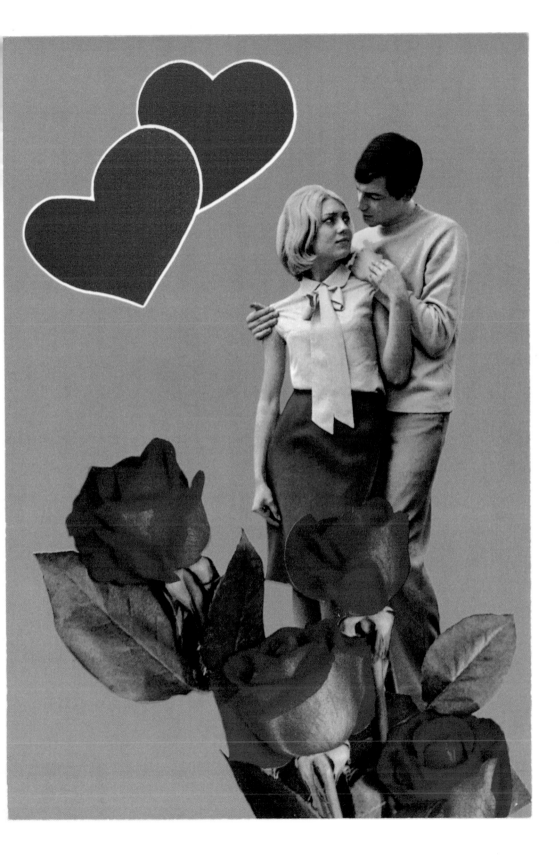

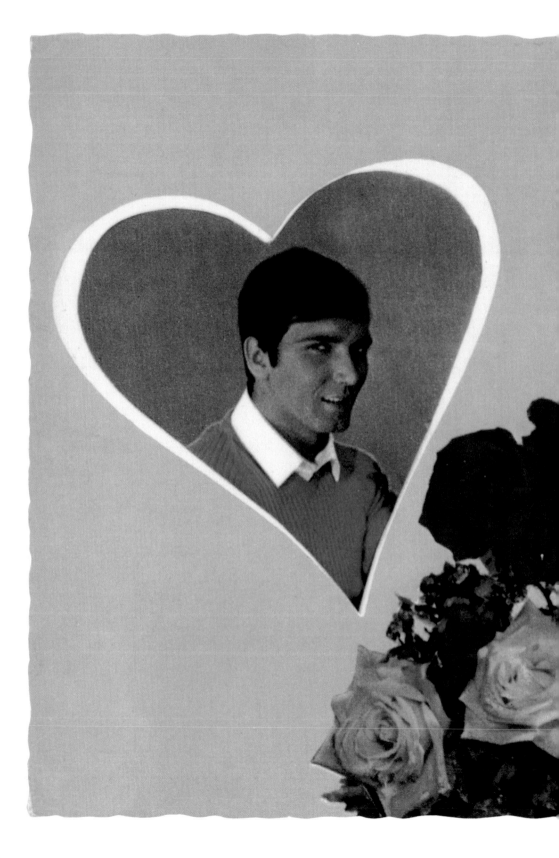

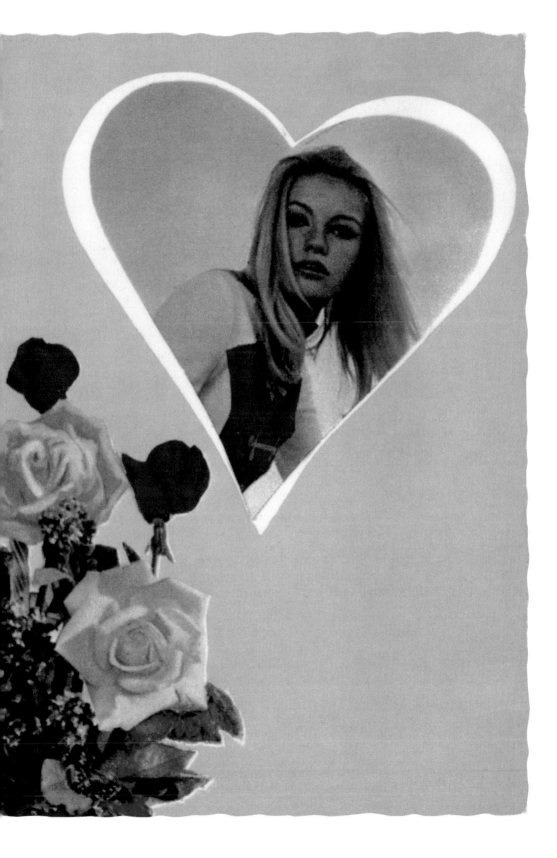

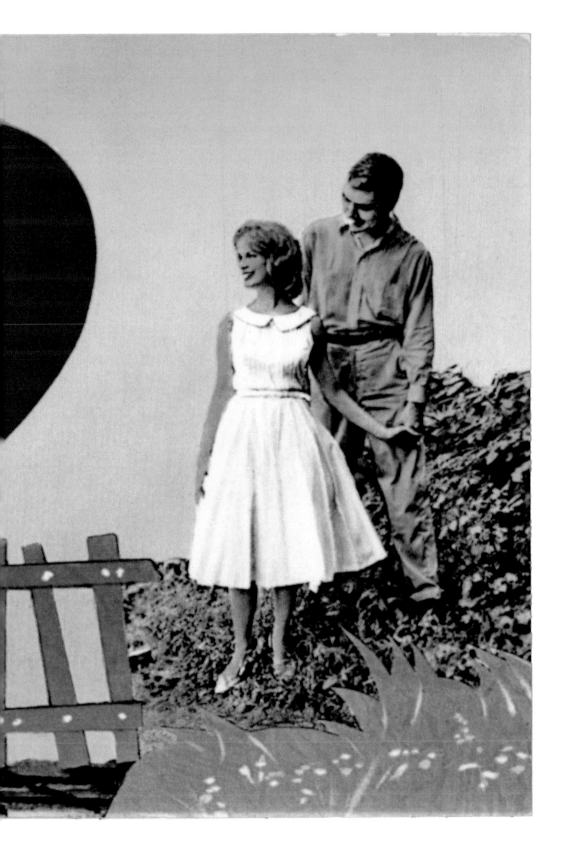

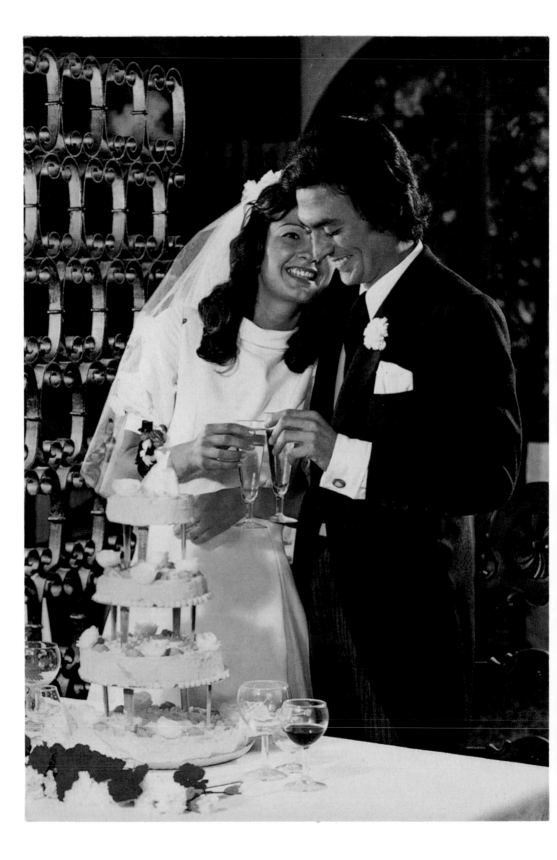

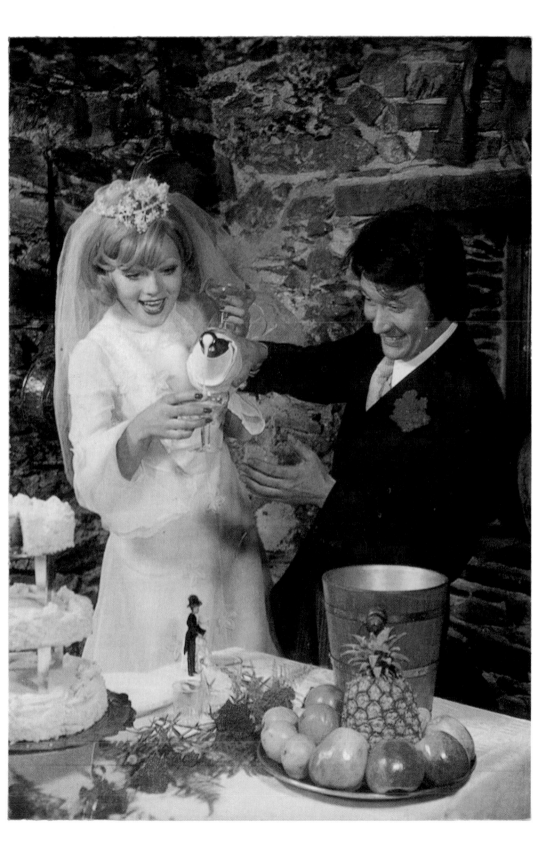

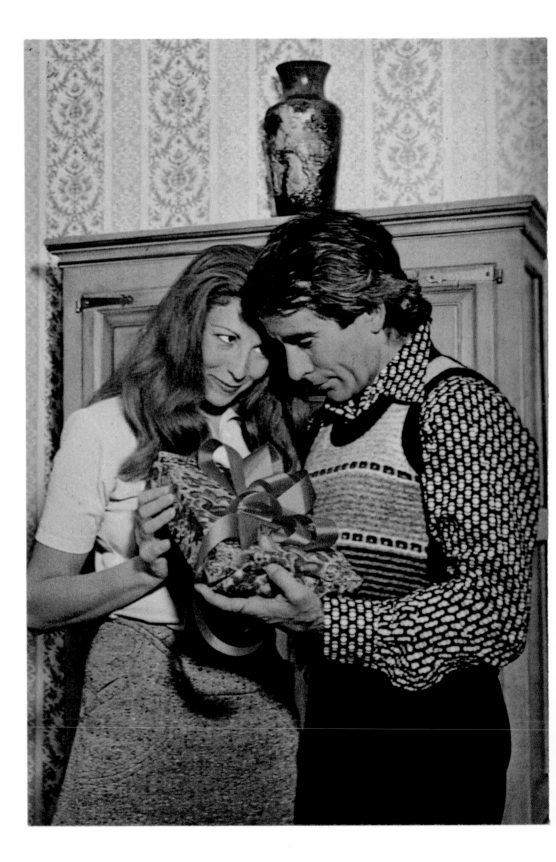

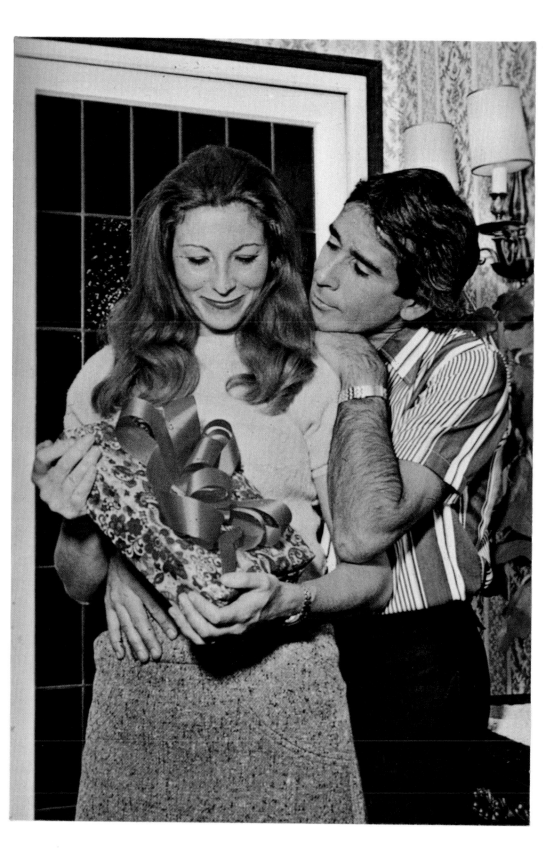

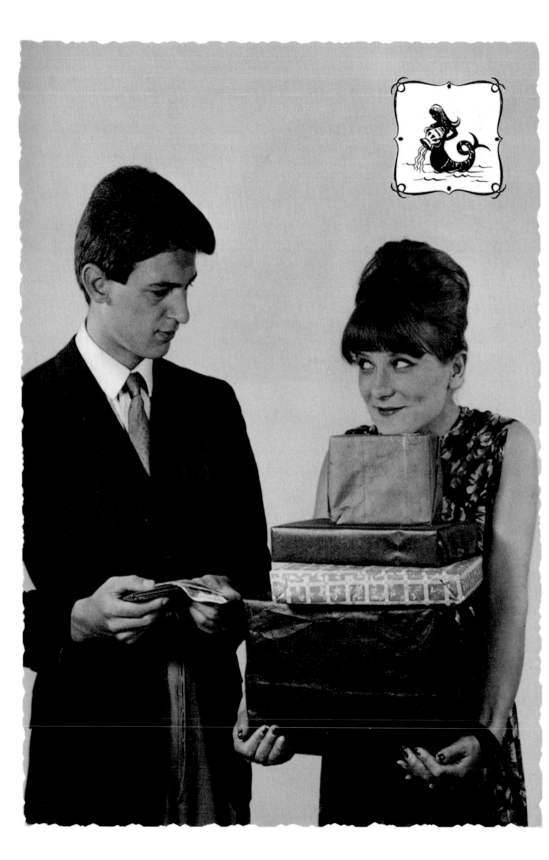

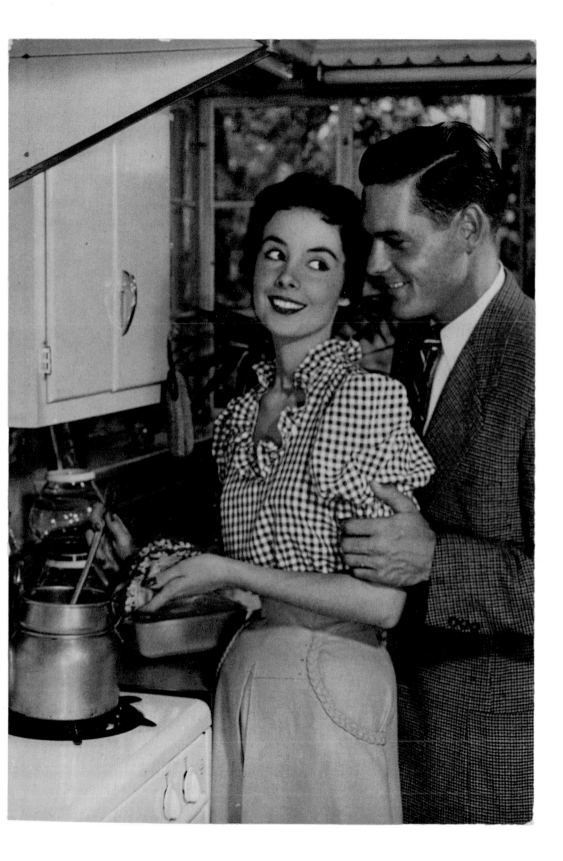

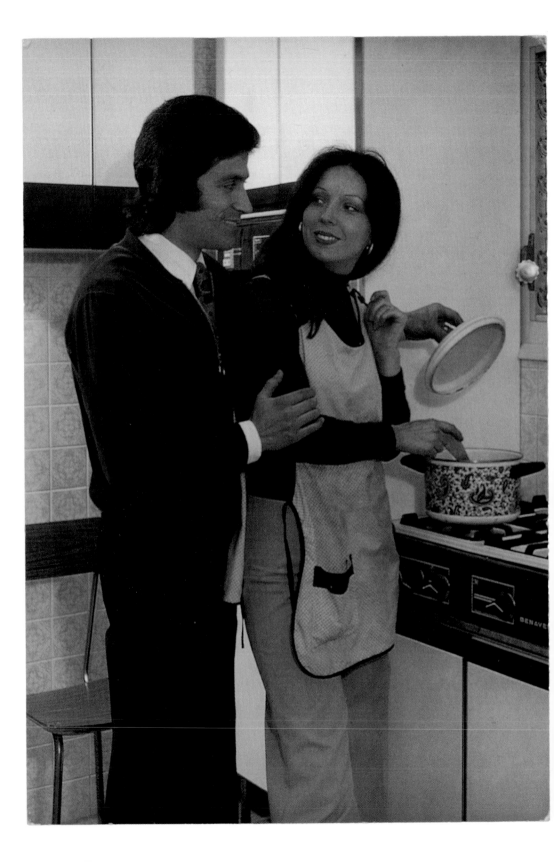

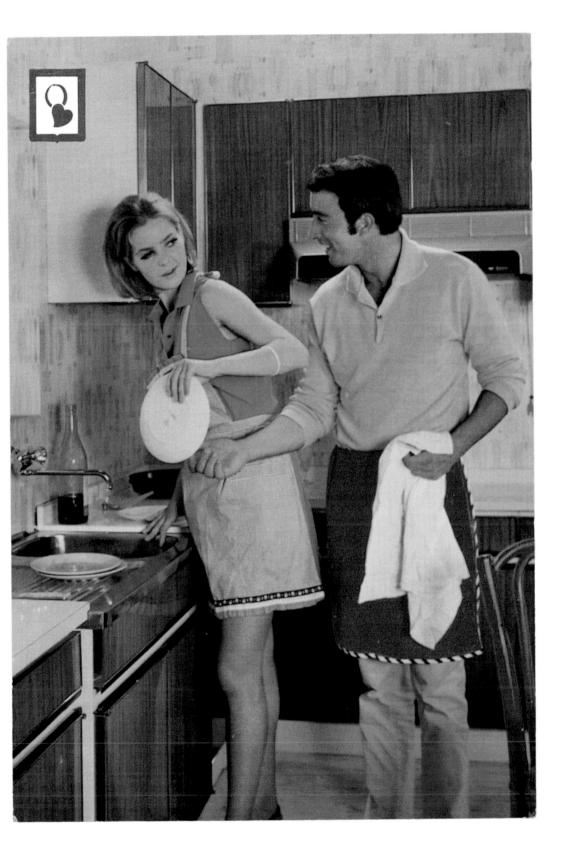

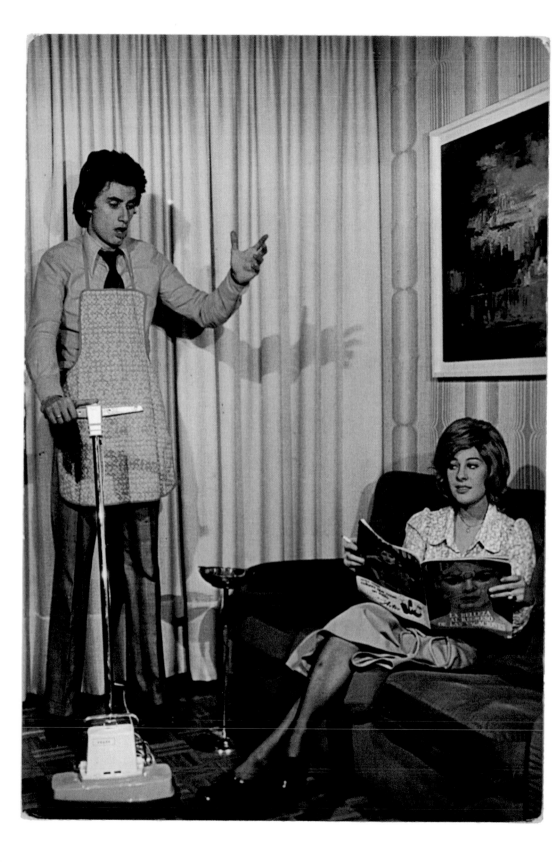

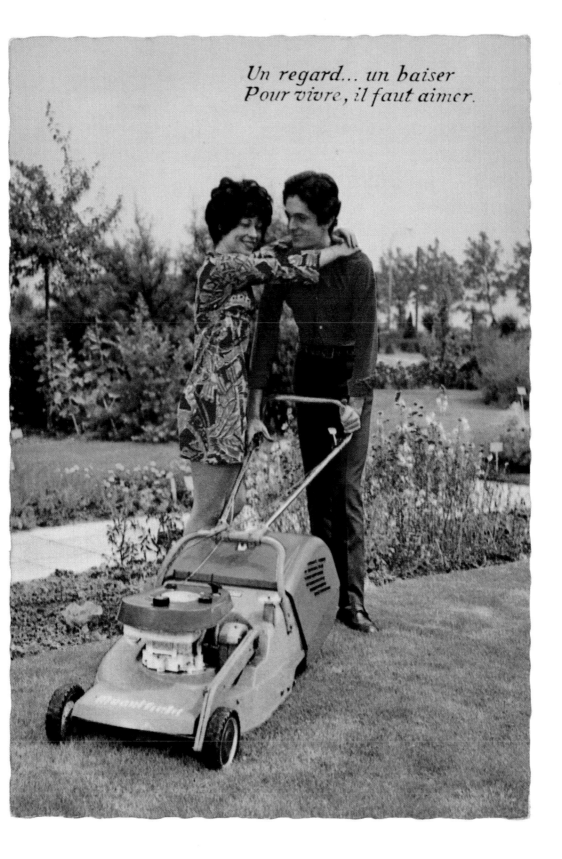

Un regard... un baiser
Pour vivre, il faut aimer.

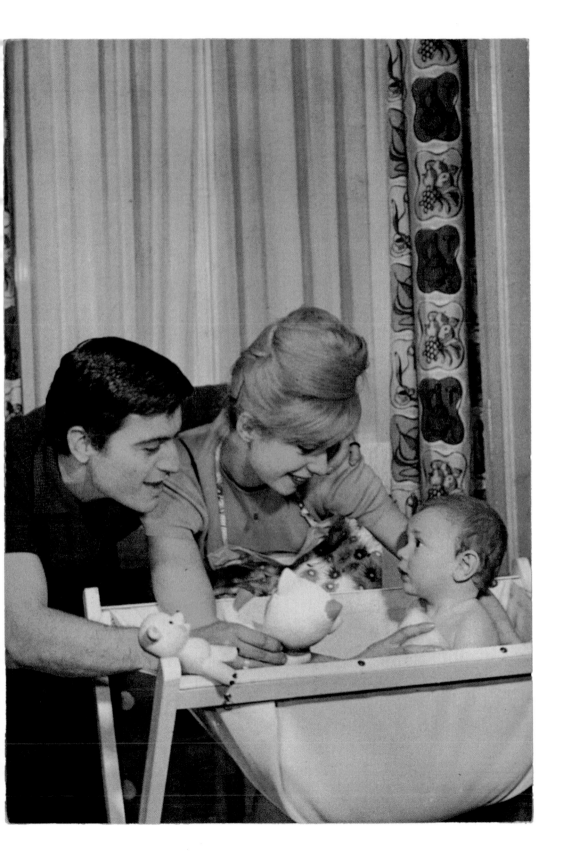

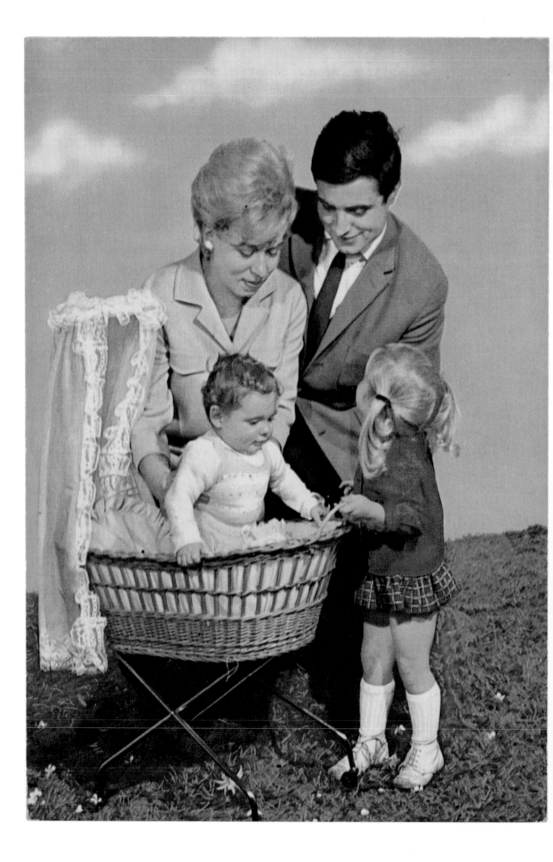

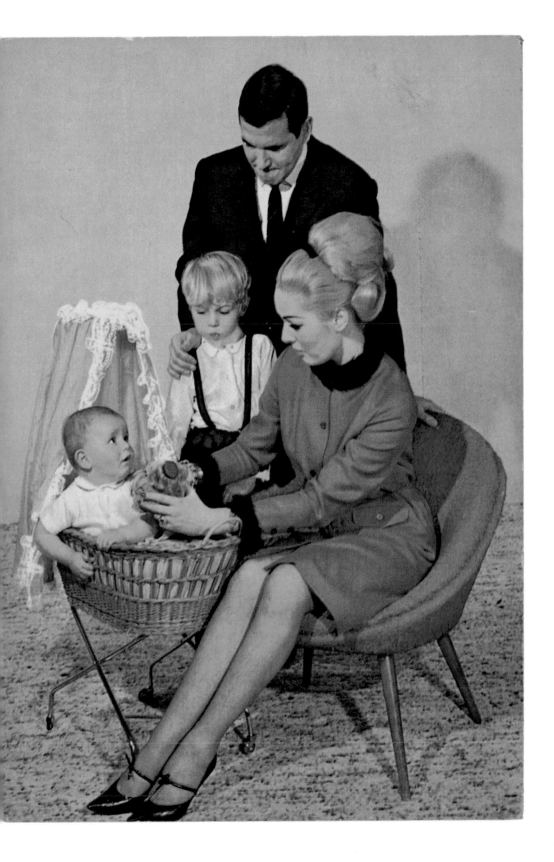

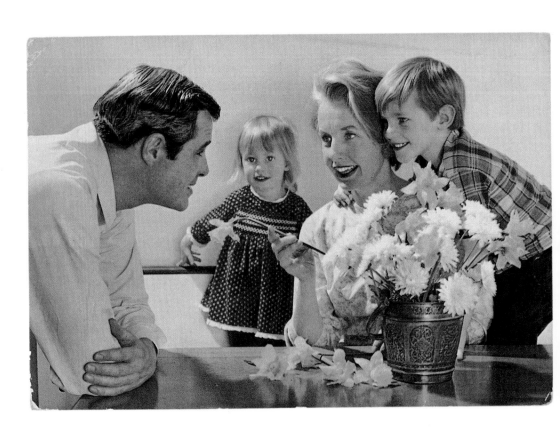

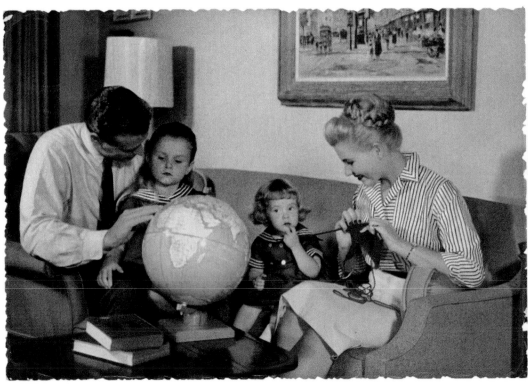

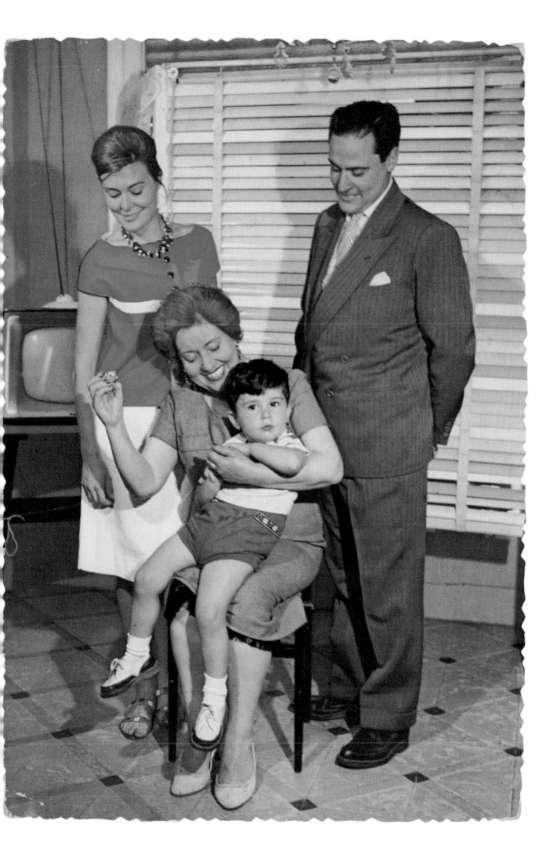

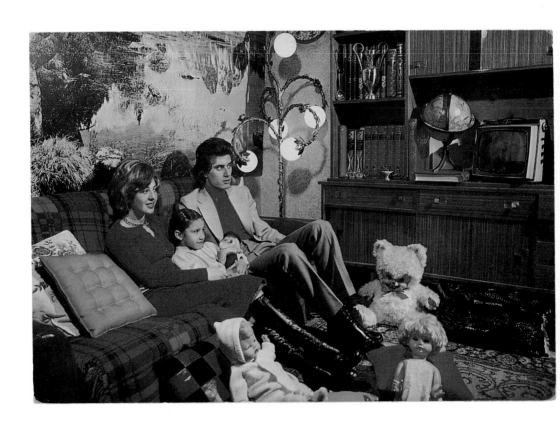

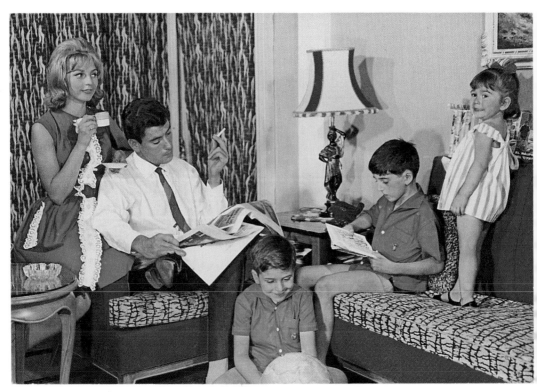

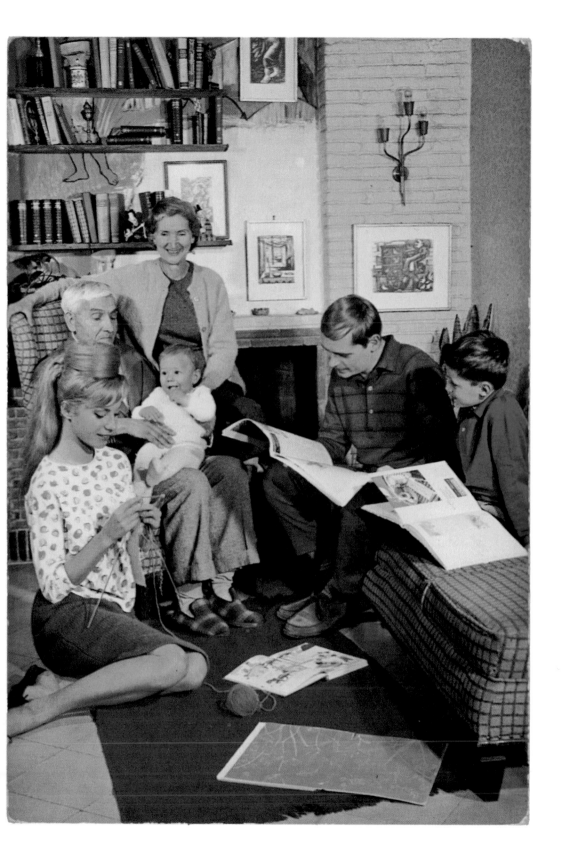

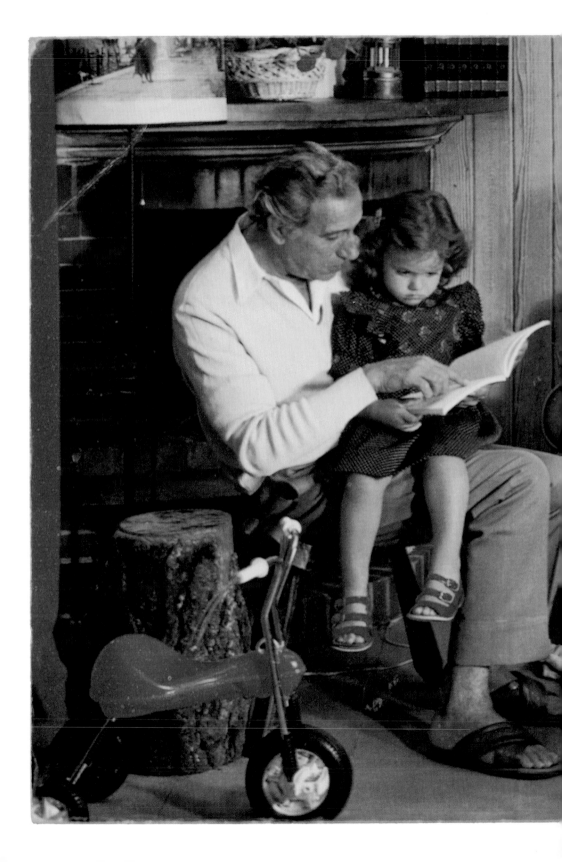

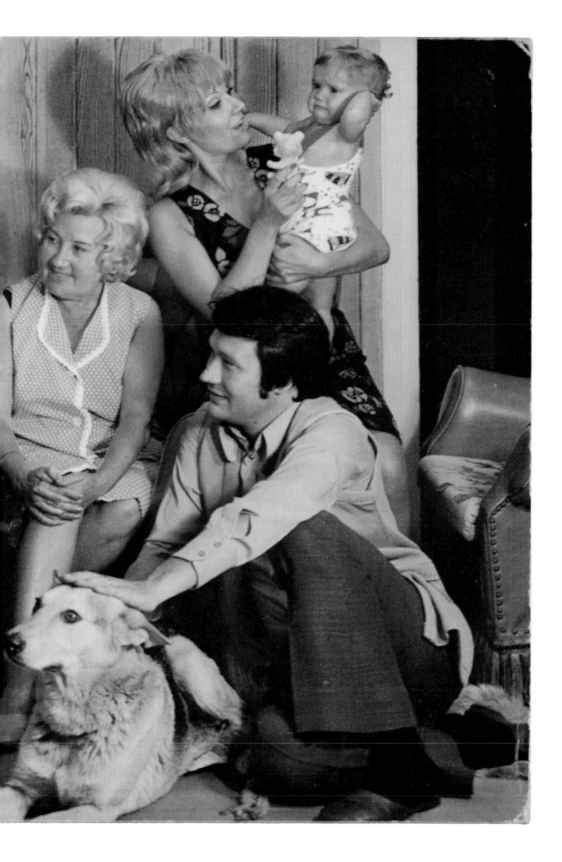

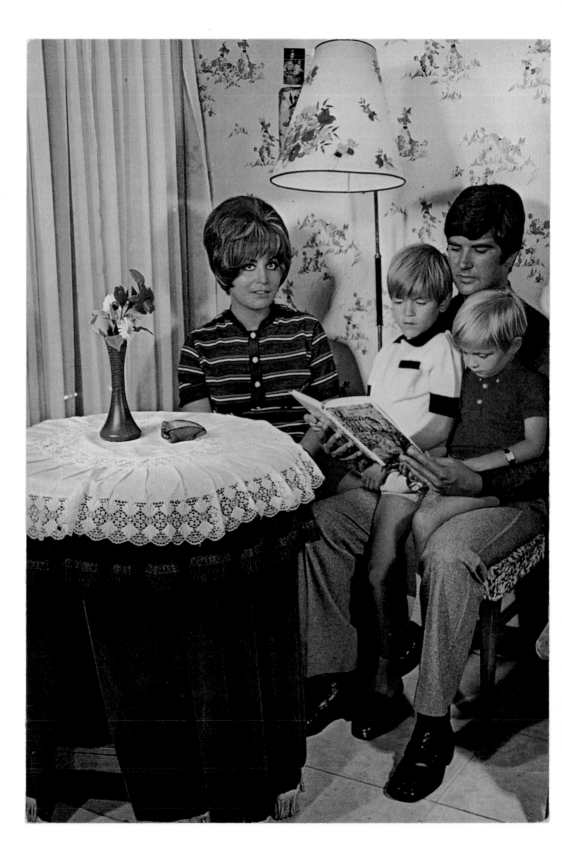

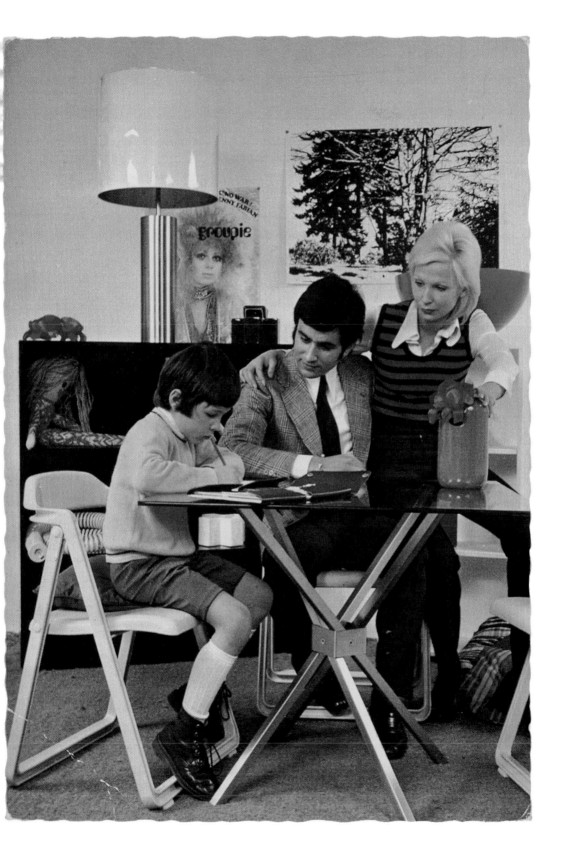

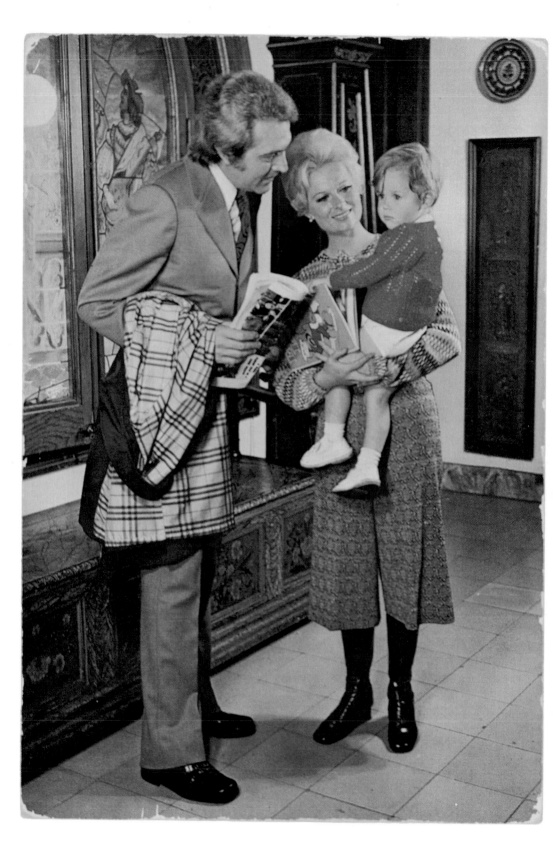

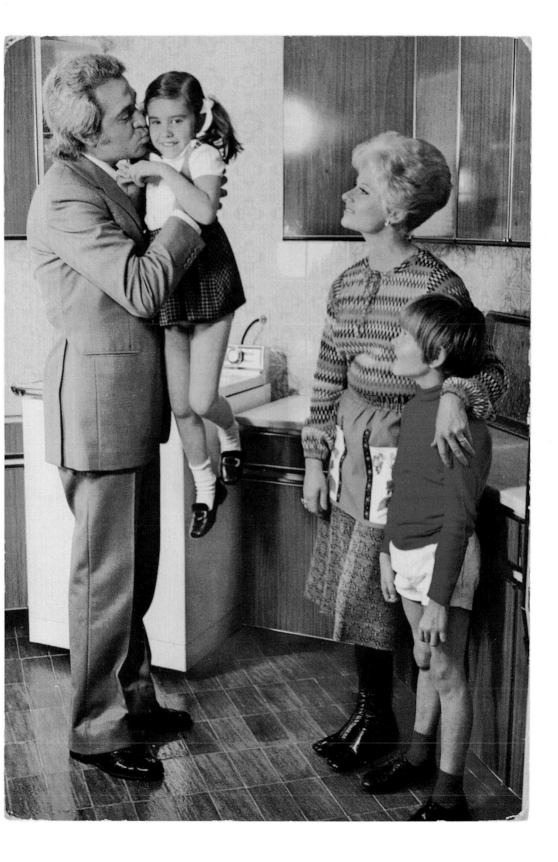

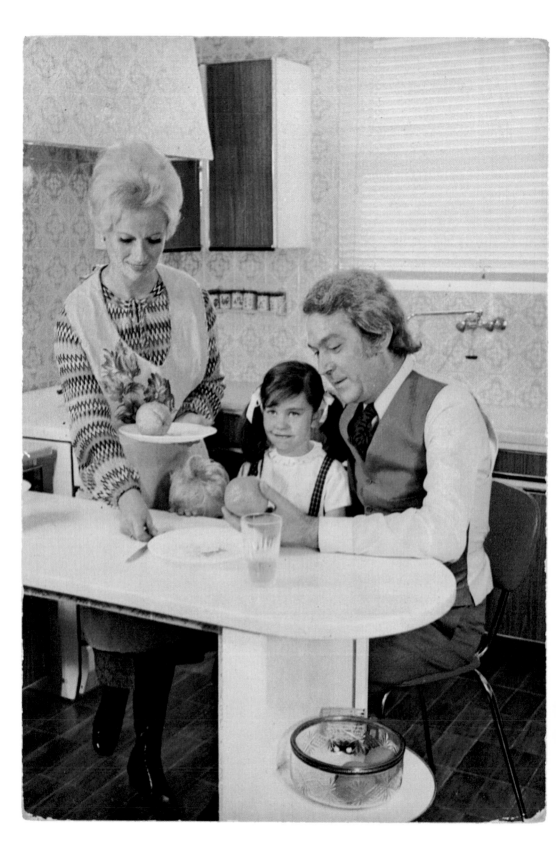

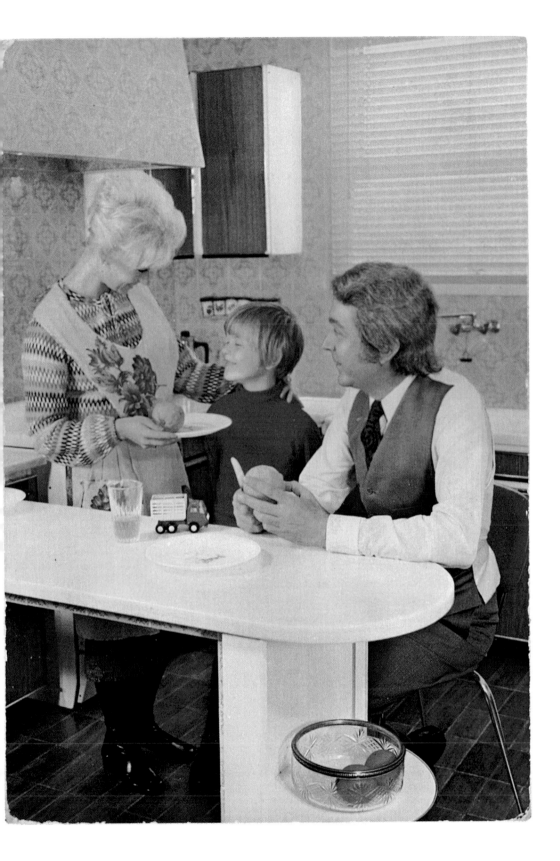

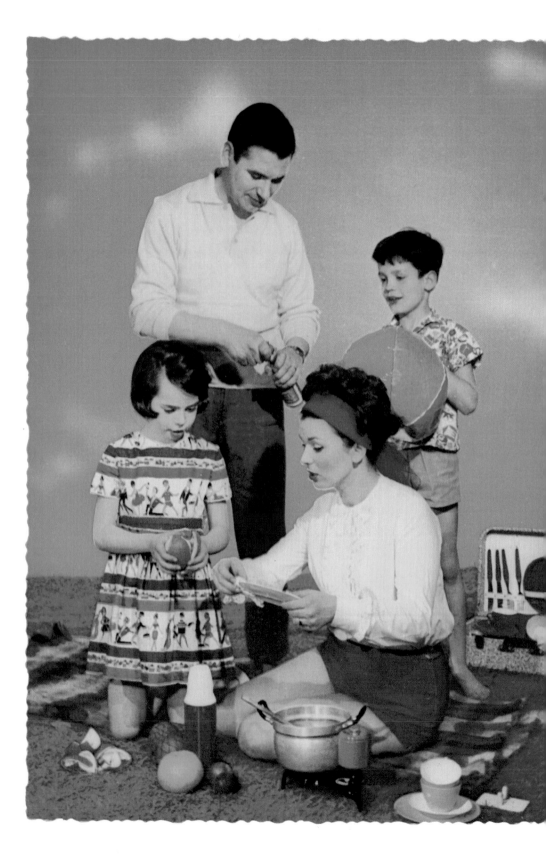

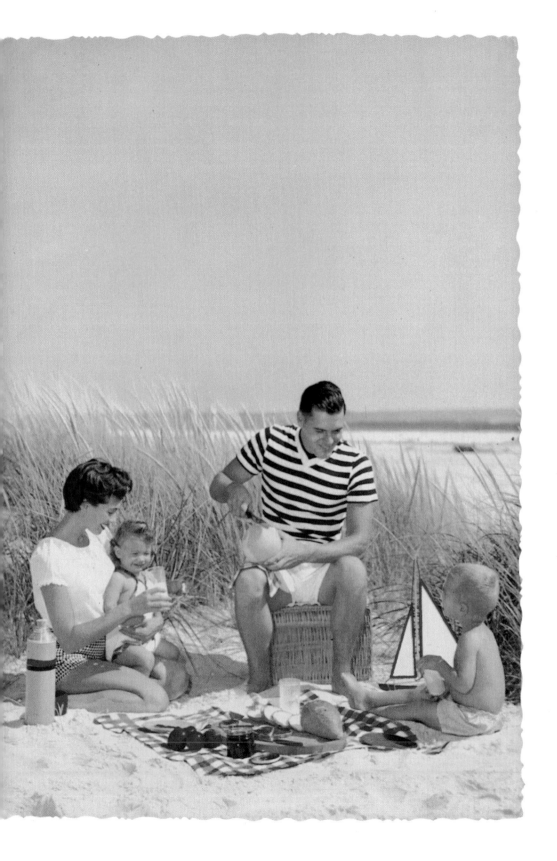

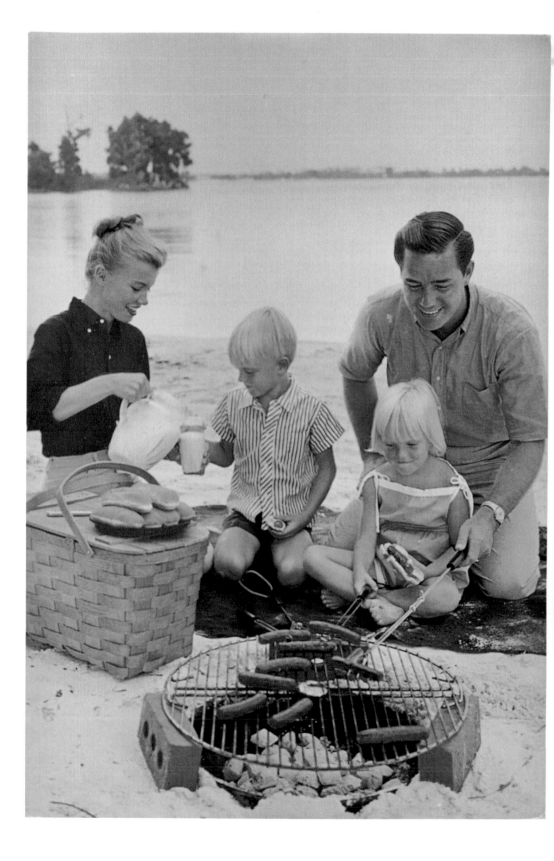

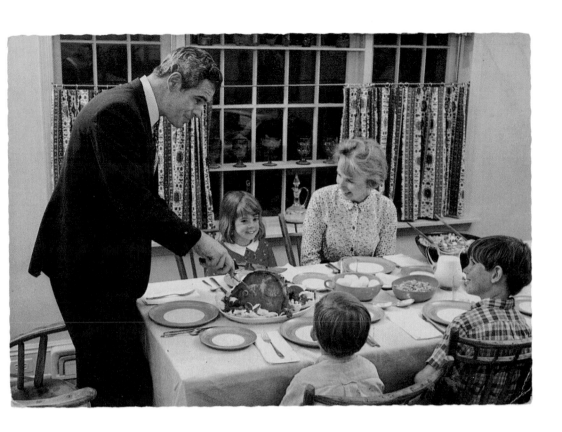

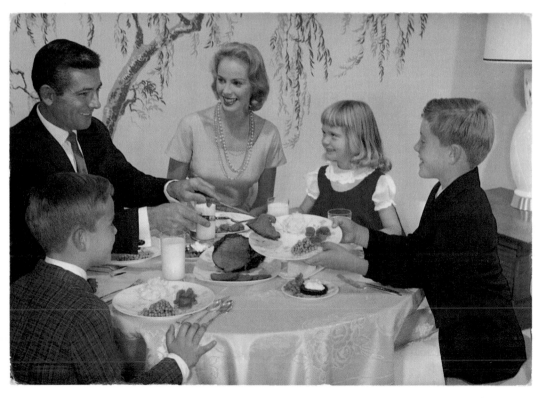

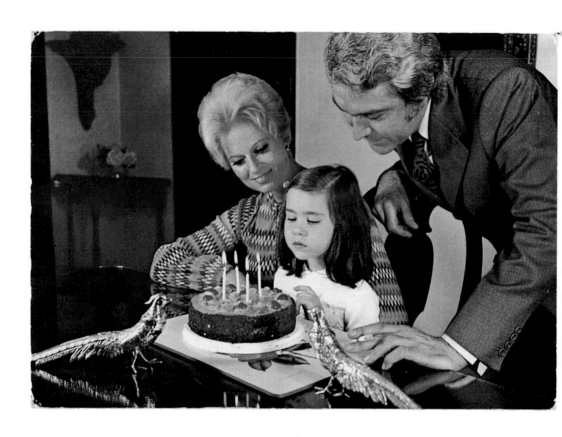

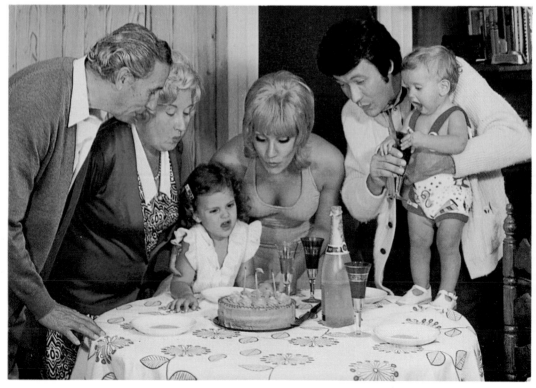

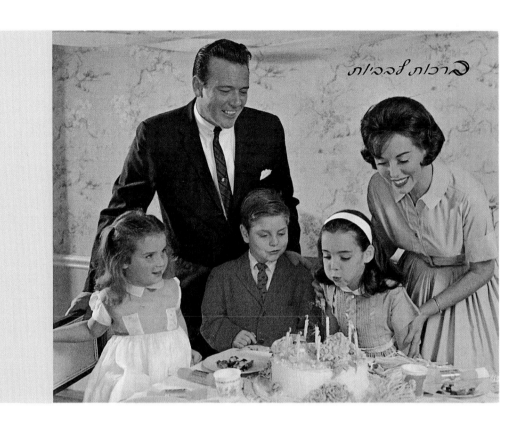

ברכות לבבית

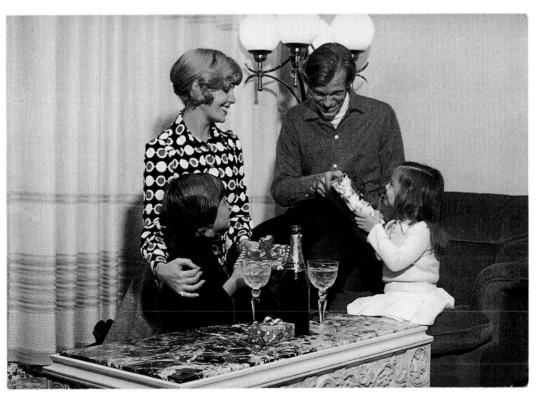

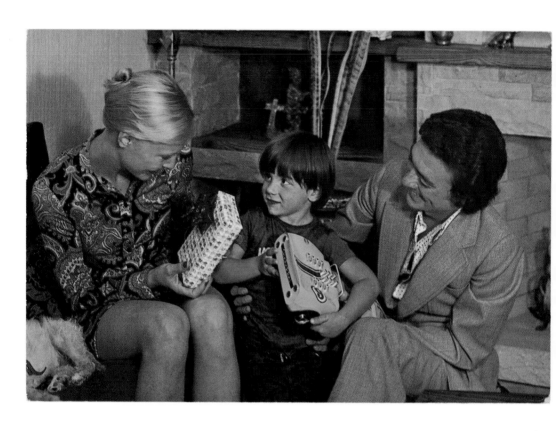

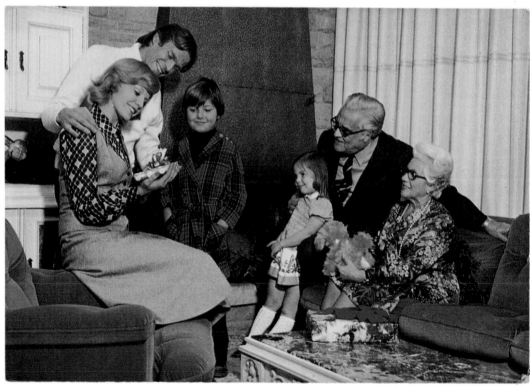

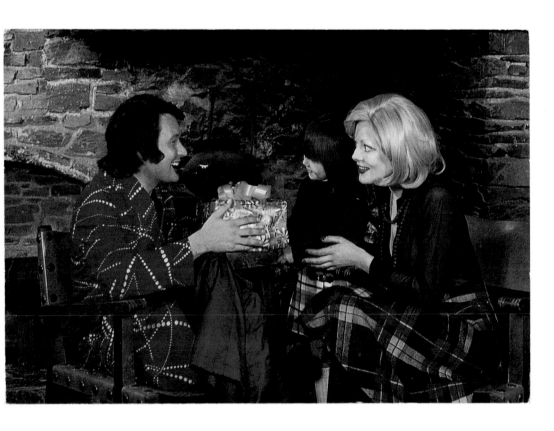

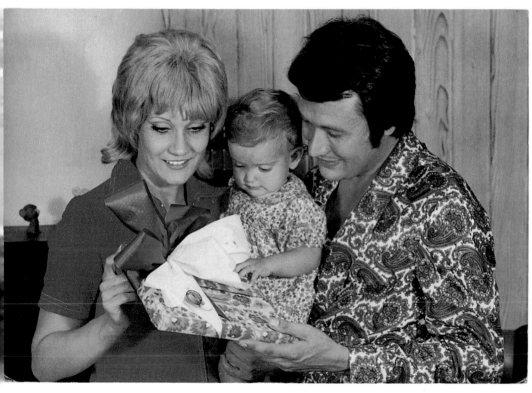

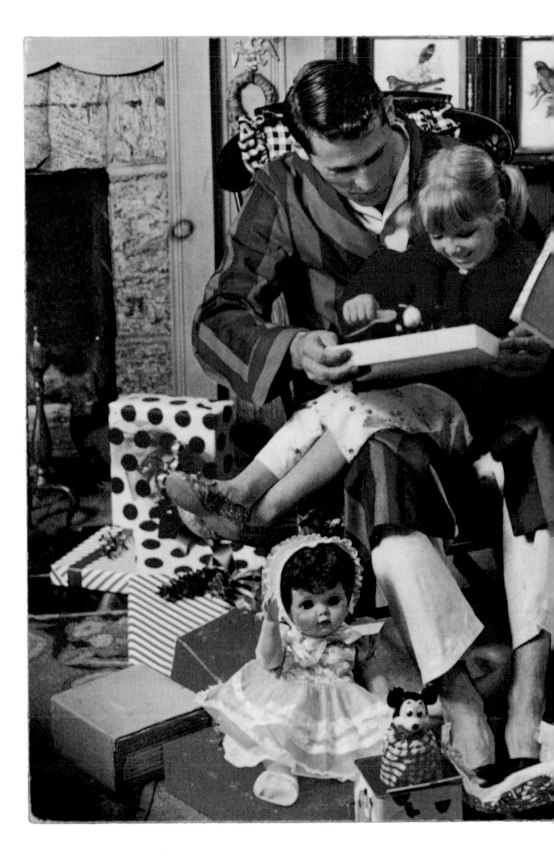

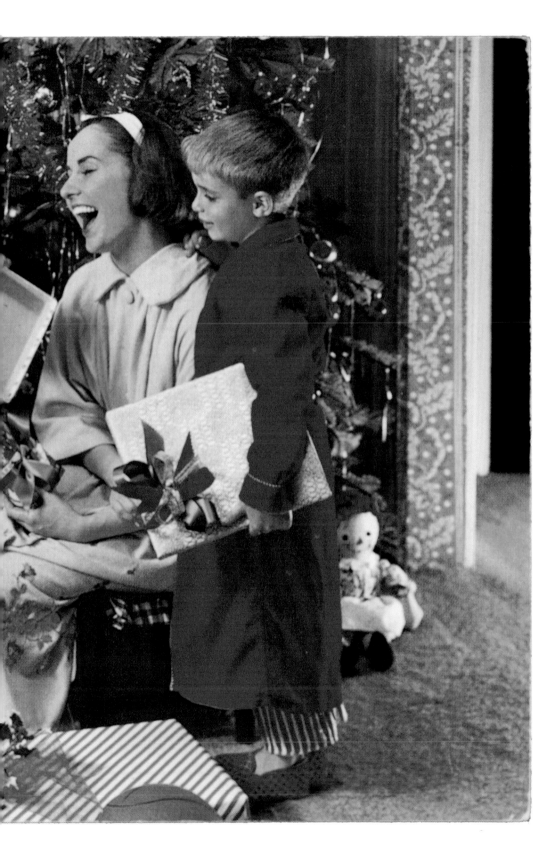

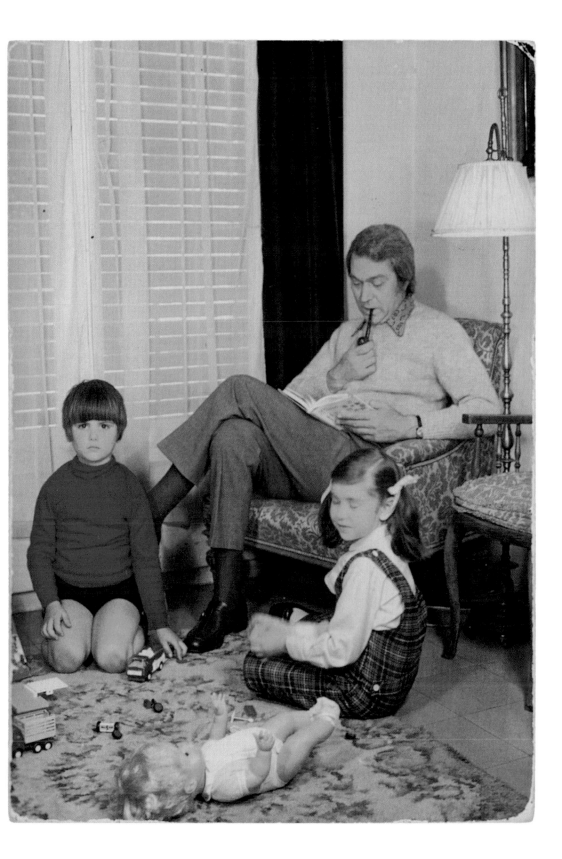

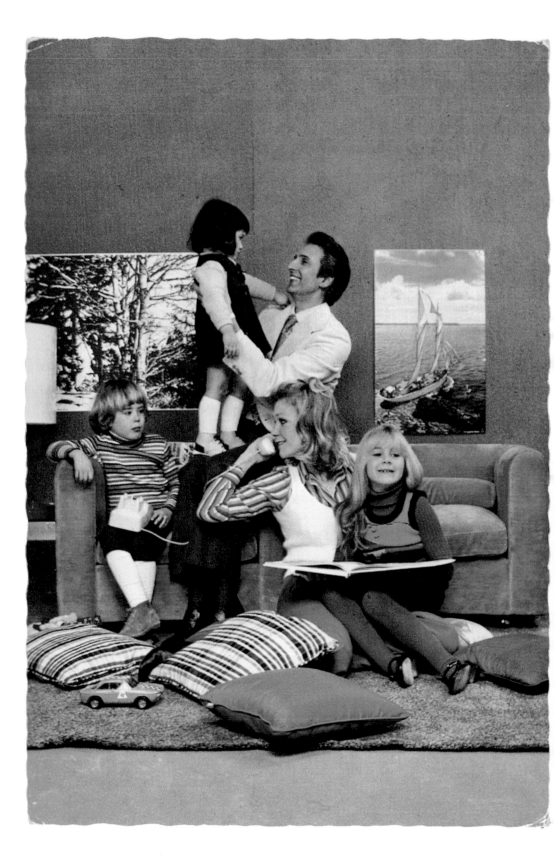

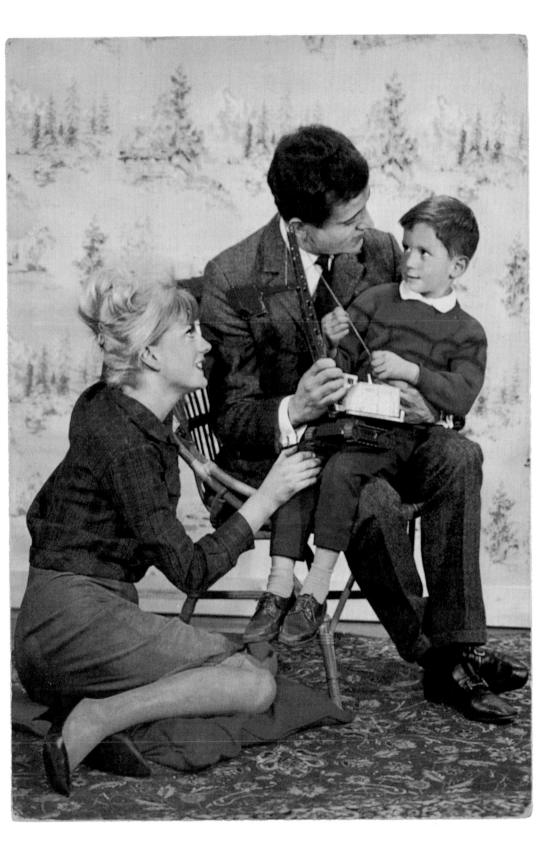

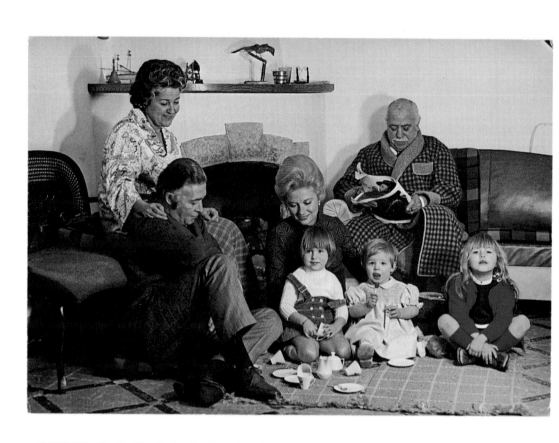

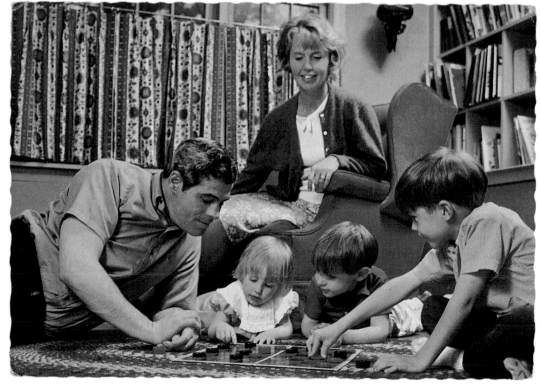

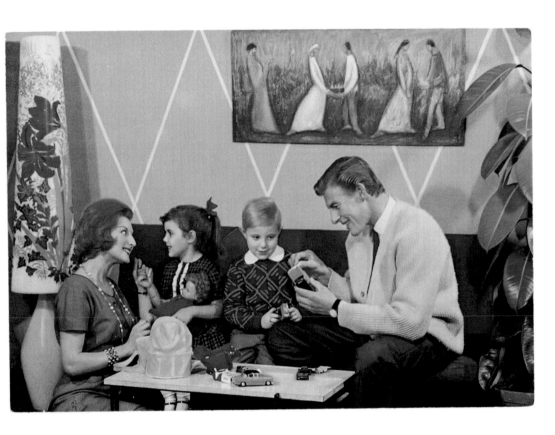

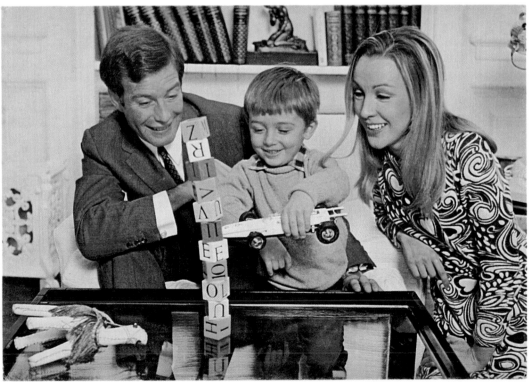

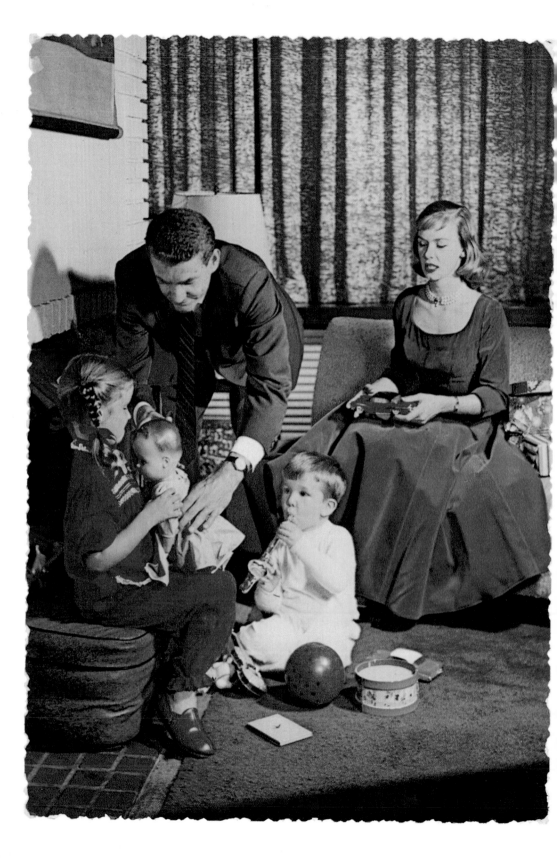

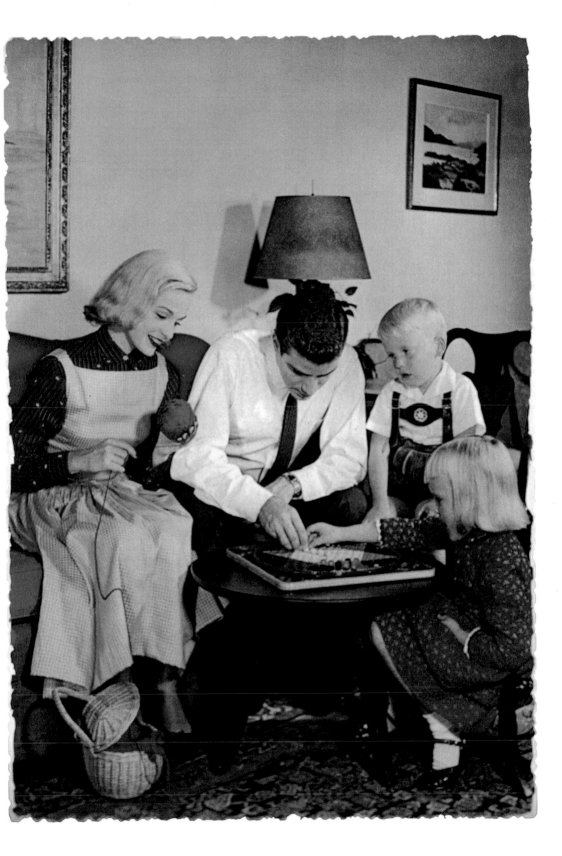

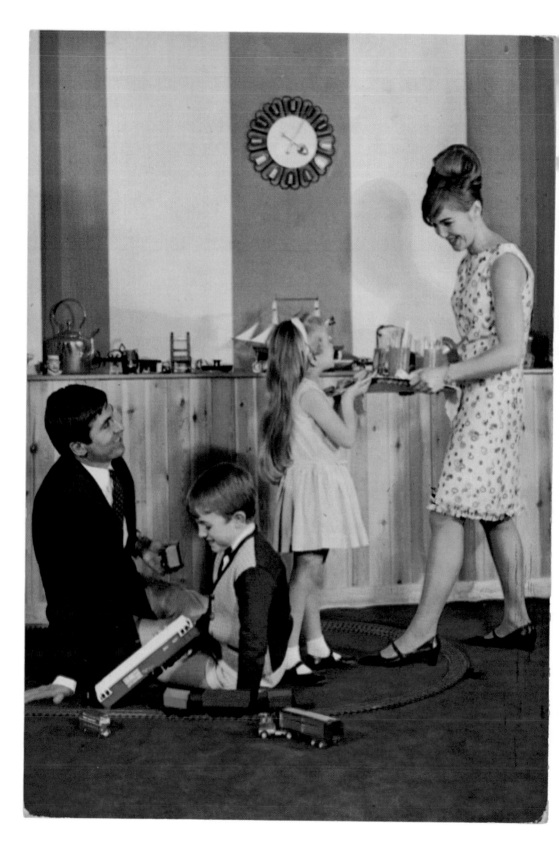

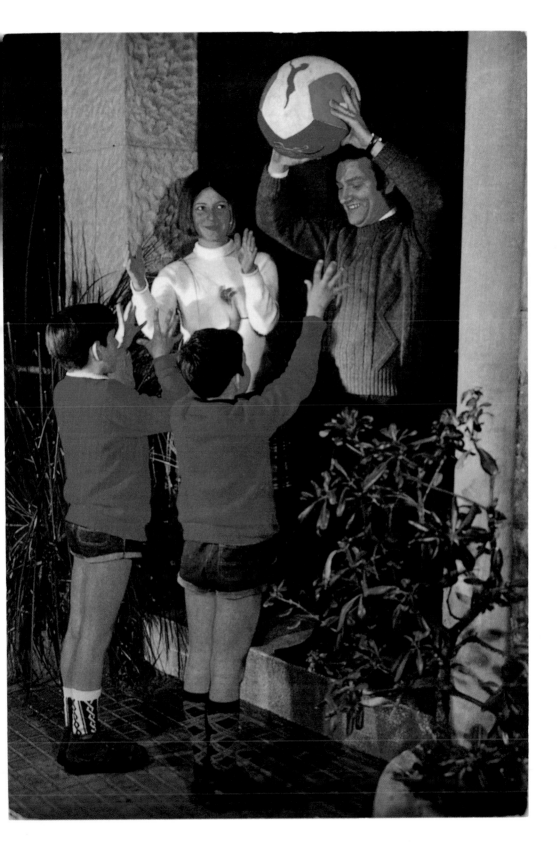

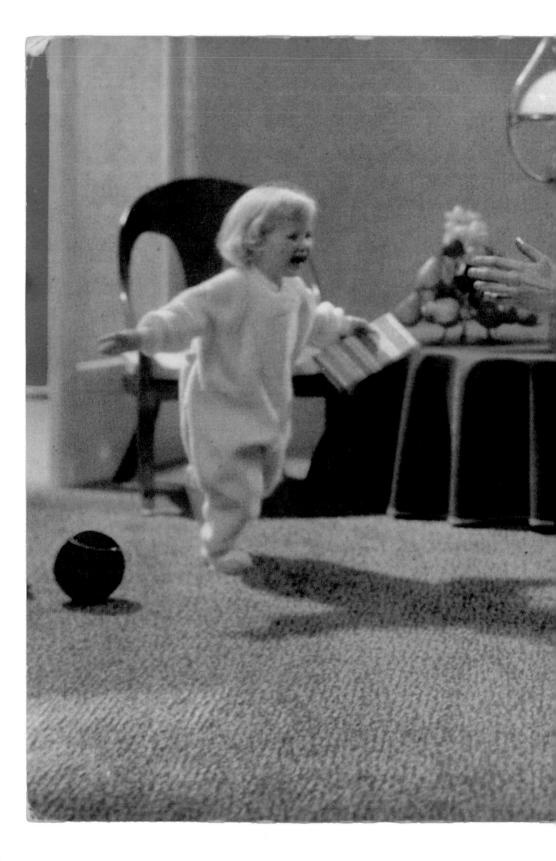

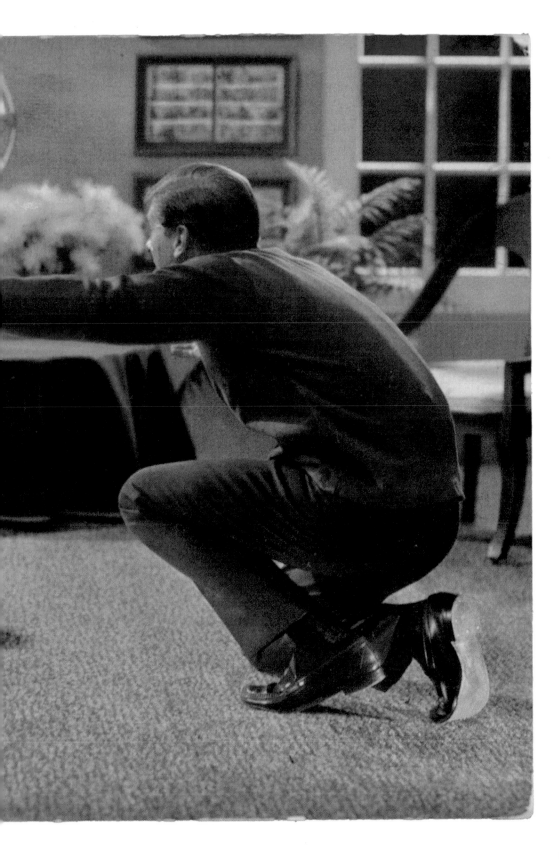

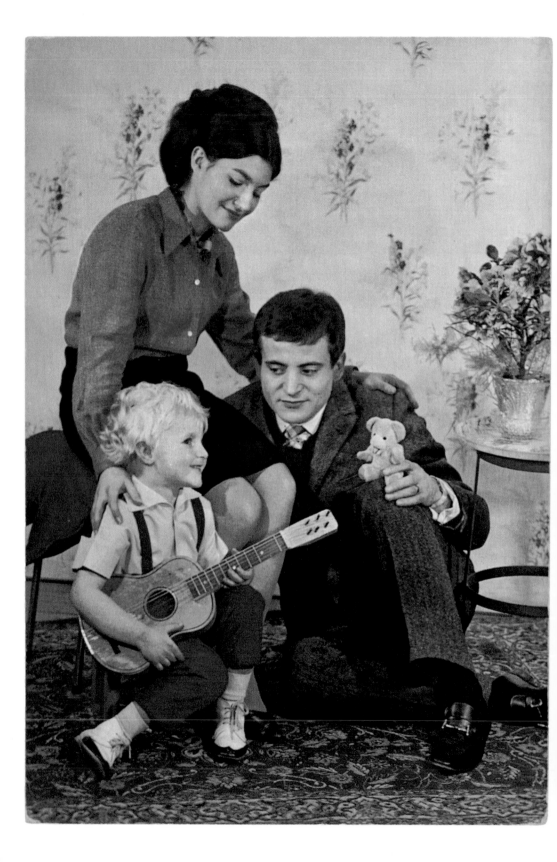

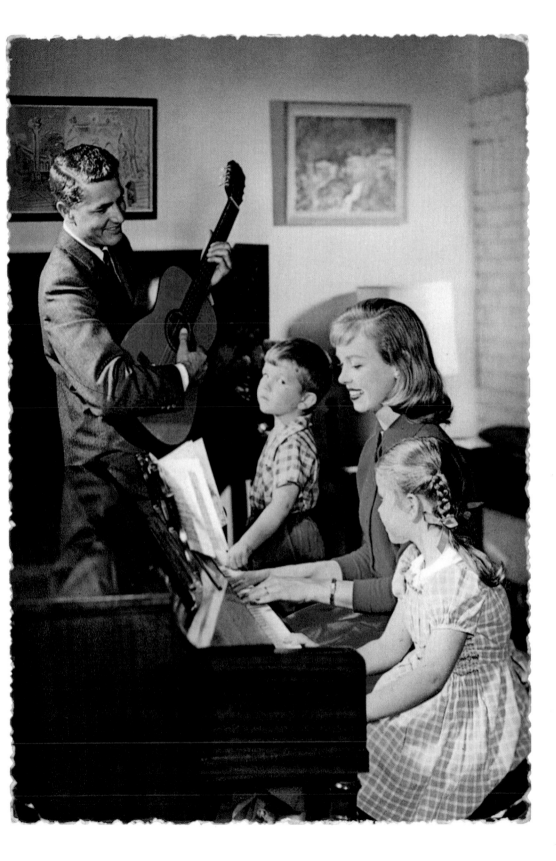

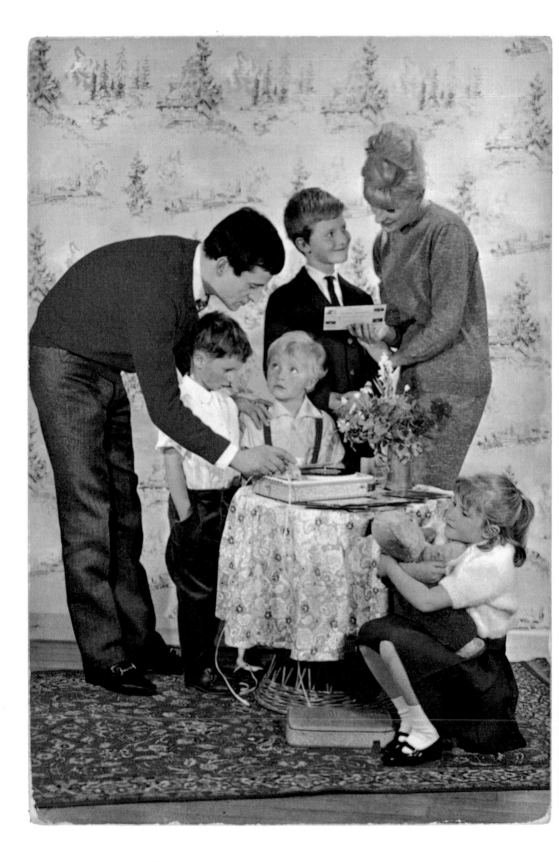

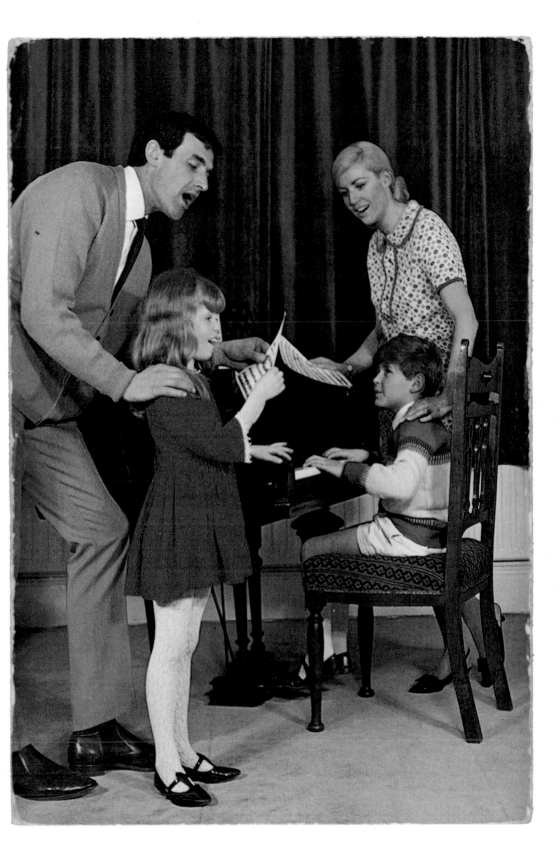

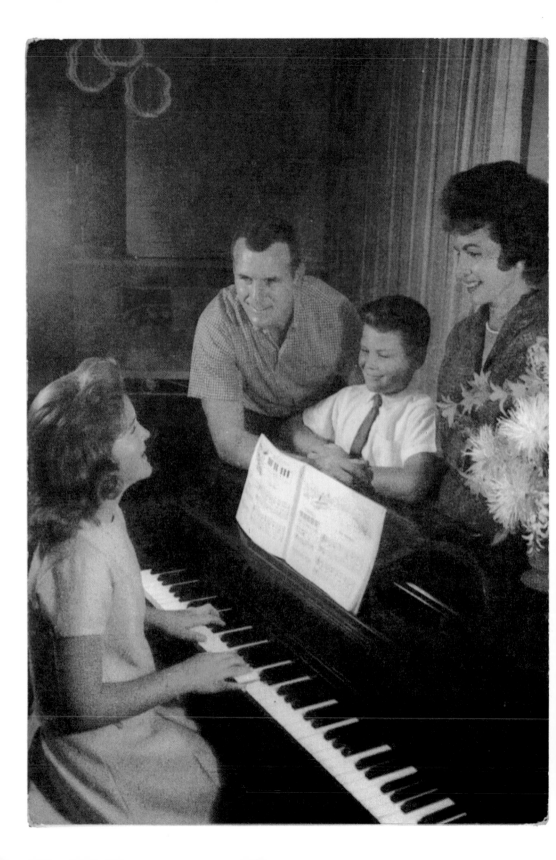

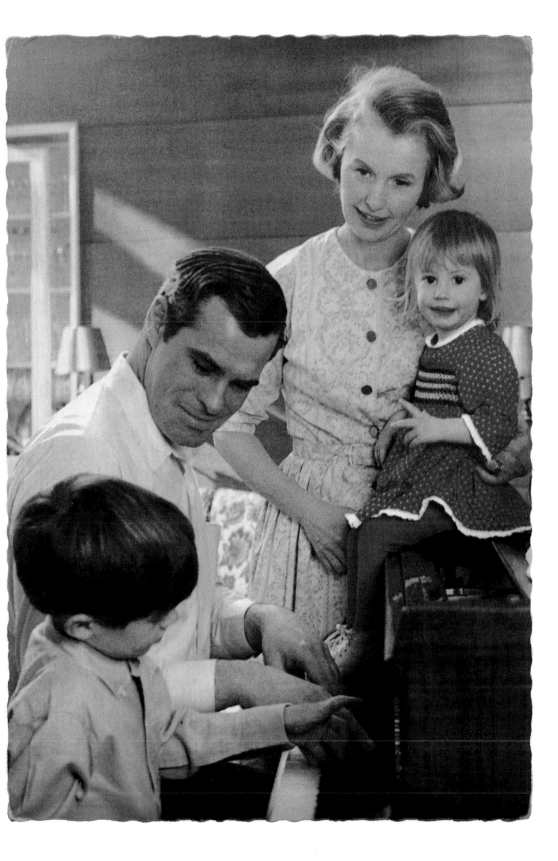

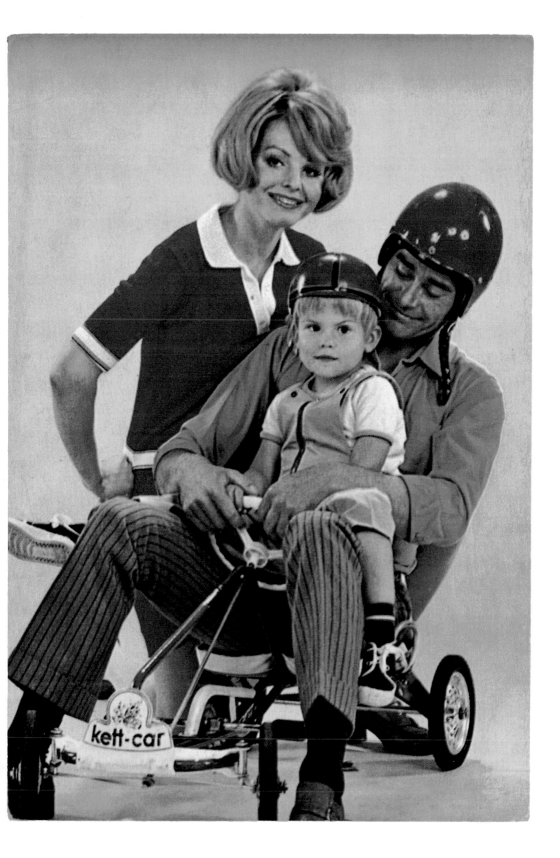

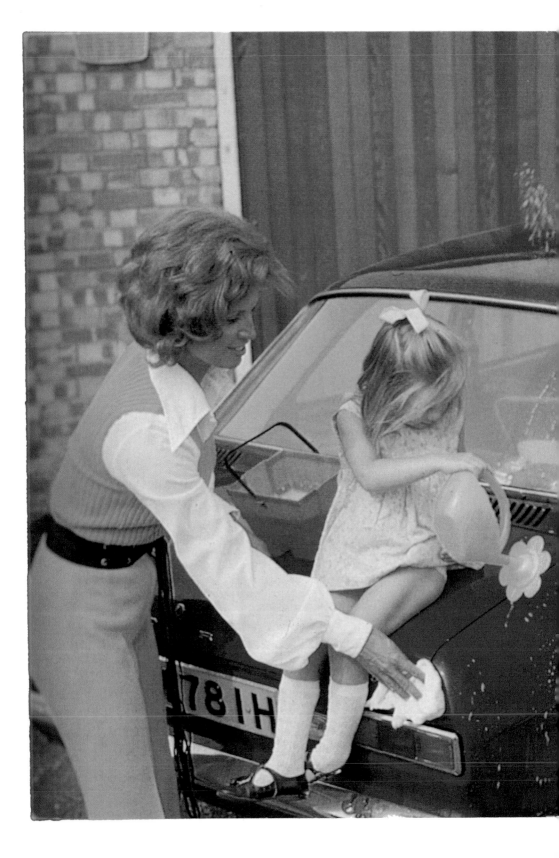

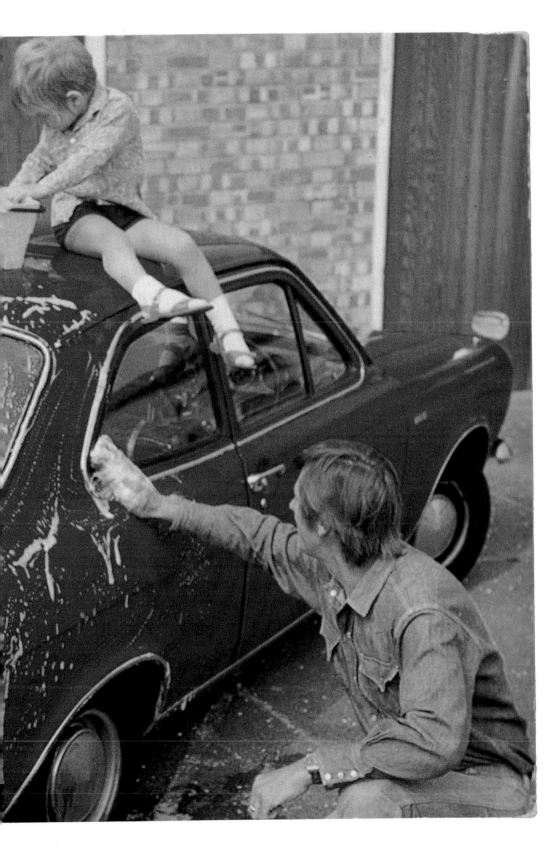

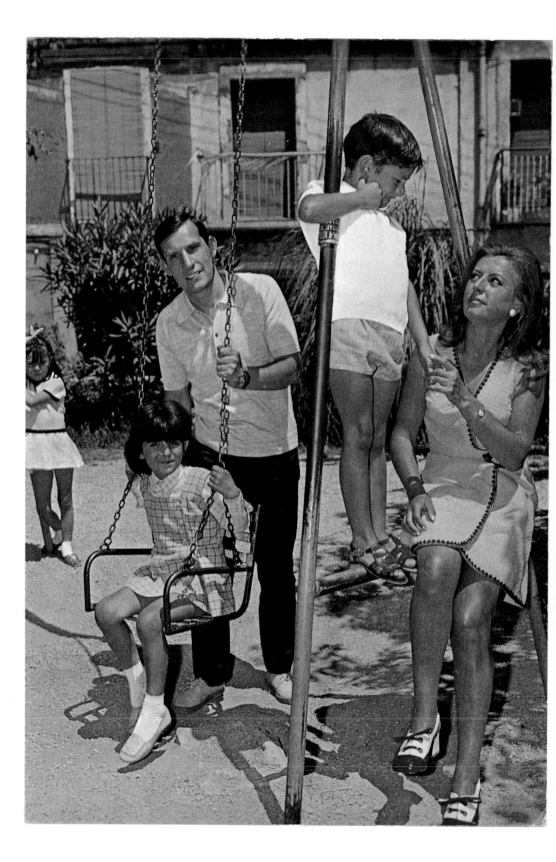

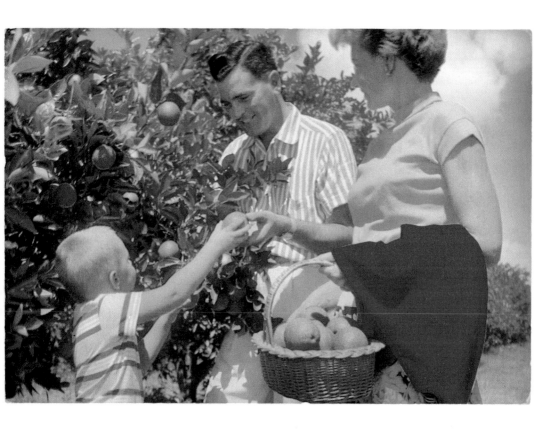

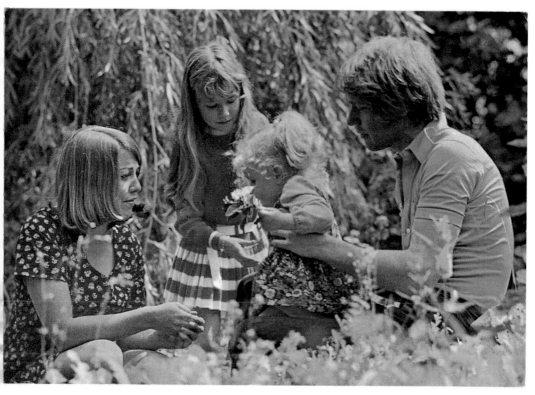

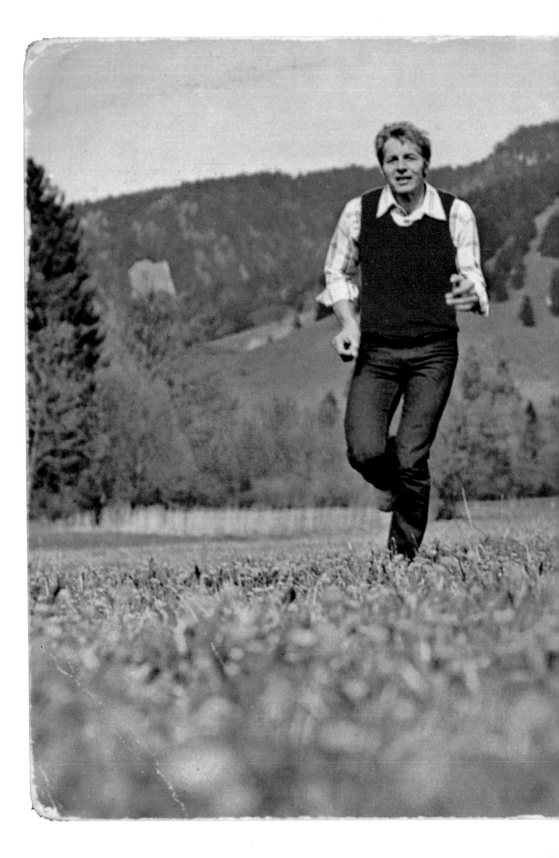

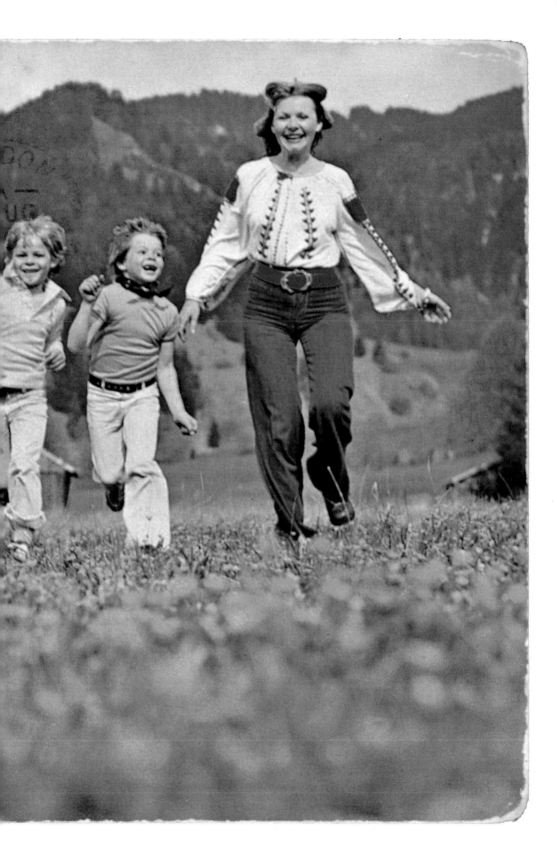

Bliss: Postcards of Couples and Families
Collection Martin Parr
© *Chris Boot Ltd*

First published 2003
by Chris Boot Ltd
79 Arbuthnot Road
London SE14 5NP
www.chrisboot.com

Design by Frost Design, London
www.frostdesign.co.uk

We have endeavoured to trace the producers
of all the postcards featured in this
book in order to seek permission for their
reproduction. We apologise to all those
we have been unable to reach.

With thanks to Stella Bloise at Cecami
(Milan) and Carlos Rivas Jr at Graficas Savir
(Barcelona) for kindly allowing us to
reproduce their postcards. Thanks also to Zoe
Bather, Frédérique Dolivet and Vince Frost.

A CIP catalogue record for this book
is available from the British Library.

All rights reserved. No part of this publication
may be reproduced, stored in a retrieval
system, or transmitted in any form or by any
means, electronic, mechanical, photocopying,
recording or otherwise, without the prior
permission of the publisher.

ISBN 0-9542813-3-0

Printed in the Czech Republic